THE RIGHT WAY
TO DRAW

Mark Linley

RIGHT WAY

Typeset in 12/14 pt Cantoria by Letterpart Ltd., Reigate, Surrey.

Printed and bound in Great Britain by Guernsey Press Co. Ltd., Guernsey, Channel Islands.

The *Right Way* series is published by Elliot Right Way Books, Brighton Road, Lower Kingswood, Tadworth, Surrey, KT20 6TD, U.K. For information about our company and the other books we publish, visit our website at www.right-way.co.uk

CONTENTS

INTRODUCTION

You can learn to draw
Yes, you really can! Many people think that learning to draw is difficult, if not impossible. In fact, it need not be. If would-be artists treated the subject as fun and went about it in the right way, it could be possible for nearly everyone — just like learning to drive. At first it may seem hard, but not if the basic instruction is correct.

Expect mistakes
When tackling any new skill it is common sense to expect and accept that lots of mistakes will be made. It's part of the learning process. It is not unusual for students with no previous experience of draughtsmanship suddenly to discover that they can put down accurately what they see. It requires just three things:
1. The ability to look properly.
2. Self-confidence.
3. The capacity to remember and carry out basic instructions.
I have not mentioned skill with pencil, pen or brush. The reason is because all who can write their names already have sufficient touch and control to make a multitude of complex shapes — the English alphabet.

There are no harder lines, in nature, to record. A semi-illiterate navvy with scarred, calloused, insensitive hands and a tendency to drink too many pints might start off at a disadvantage. But there are talented handicapped artists with no fingers who can draw; some even use their feet or mouths.

Think positive
Folk who learn quickly are often those who have enthusiasm for their subject and confidence in themselves. The way we think is vitally important to the way we operate. Many of us are brain-washed from childhood into thinking negatively about some things. We have all heard others say, for example, "I can't draw a straight line". When this is thought or said, it becomes a command to the human computer, the sub-conscious mind, which then obeys the instruction by programming the individual to this end. "I can't" is then a barrier for as long as it is thought.

Think negatively and you will be programmed to do exactly what you have thought. You will never be able to control a pencil or a pen well enough to put down the lines you see. You won't be able to observe shape accurately, or define texture, and, of course, it will be your own fault.

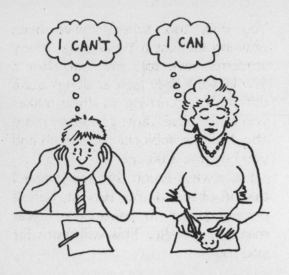

You have bought this book, so you are probably already a positive thinker; if not, you will be from now on. How do you do this? Very easily: just think and say "I can learn to do anything", then forget about it. How long will it take? About a tenth of a split second, or faster. What's more, you can apply this simple rule to any subject for the rest of your life. You will have no barrier to stop you moving forward. It may encourage you to know that I am a self-taught artist.

Gifted?

I believe the term 'gifted' is too lightly used in respect of artists. Only one in every million or so can truly be said to be gifted. The rest of us are craftsmen with different degrees of skill. If you can write your name then you have enough touch to learn to draw. If asked to write an A, G, R or K you could do it without thinking. Well, within these pages you will not be called upon to draw anything harder than that. Most

lines in nature are gently curved, wavy or straight; even those that appear complicated at first are not, if examined closely.

This is why it is vitally important for artists like us to look properly at what we want to record. If our drawing goes wrong it is because our looking was at fault. If, for example, you draw your spouse with a broken nose, cauliflower ears and crossed eyes, when in fact the features are more or less normal, then your viewing is wrong or your humour wicked! If your sketch of the family moggy turns out to resemble a furry crocodile, then you haven't focused correctly, or you need glasses.

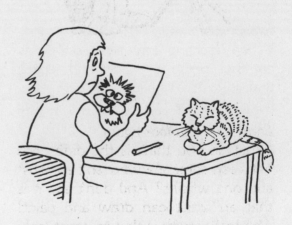

A note for children — of all ages!

This book is designed to be used by children and adults alike! Most children are natural artists. They fearlessly tackle a wide range of subjects: animals, cartoons, people, monsters, countryside scenes and many other interests. Often, adults don't have the same imagination or spirit of adventure!

When children — and grown-ups — go wrong with their drawing, it's simply because they haven't been shown or told how to go about it. This book will put children of all ages on the right path to becoming jolly good artists.

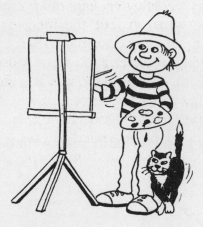

Look, look and look again

What do you think is the difference between someone who isn't an artist and one who is? And don't say it is that an artist can draw and paint! The real answer is that an artist *looks* at things differently from other folk. We all see trees, for example, but do we notice what the trunk is like, the bark, branches, twigs and leaves? Do we note that there are dark and light patches? Can we see that there are many different colours in just one tree? If we aren't artists, then probably not.

An artist takes a good look and absorbs all the information in one go.

You will, too, when you've been drawing for just a short time. Many students have told me that after a few lessons they look at things quite differently. Learning to draw makes you more observant, you learn more about all the subjects you sketch and you become a bit special.

I've always found that the longer I take in observing my subject, before putting pencil to paper, the fewer mistakes I make. This will work for you too.

Churn them out

Some amateur artists believe they're doing well if they turn out three or four drawings in a week, but this is almost useless as a way to learn to draw. The more you draw the better you become. It's possible, and not hard, to draw ten subjects per hour. Prior to writing this section, I wandered slowly round a zoo and recorded twenty-six different subjects, some of which are in this book. The actual time spent on this was under two hours. One two-hour session in an art gallery produced forty quick sketches of people. This is not unusual for someone who can draw. It might seem difficult for a beginner, but if you follow the instructions given and do the assignments at the end of the chapters, you will be amazed at your progress, creative output and genius.

Always put the date on your work. When you look back you will be able to see the improvement, and this will bolster your self-confidence and enable you to go from strength to strength.

Caveman artists

Early caveman could draw and carve simply but accurately, despite his small brain! The first artists used the materials around them to paint: coloured clay, earth, plant juices, all applied with sticks or fingers. Today, we have a wonderful selection of art materials to choose from, and so we start off with a tremendous advantage.

Materials required to start

For the exercises in this book you will need a few soft lead pencils (HB, 2B and 4B), drawing pens (fibre-tipped or ball point), a small brush, an eraser and an A4 sketch pad. Details of what to use are given as we progress, and other materials will be suggested along the way. You may prefer to use crayons, coloured pencils or pens. Choose what you are happiest with. Picasso tended to use whatever was at hand. You might be following in his footsteps — who knows?

What do we draw on? Any smooth surface will do, including the tablecloth, but a good cartridge paper sketch pad with a cardboard back is the best. You may treat yourself to a classy drawing board, or table easel, but most times, particularly when sketching from life, these aren't necessary. You will also need a medium-soft eraser and something to sharpen your pencils with.

The right grip

How do you hold a pencil to draw with? The way that is most natural and comfortable for you personally. Not too tight, relaxed and under control. How do you control a pencil? Usually with your eye, brain, tip of an index finger and side of a thumb, but we all have a slightly different grip.

CHAPTER 1
INSTANT PICTURES

When I teach beginner artists how to draw they are given an easy first project to do which helps to raise their self-confidence. It is a job that doesn't require much drawing skill. In fact, most of you could do it with one eye closed!

How to make instant pictures
You will need a few sheets of drawing paper, drawing pencils graded 2B and 4B, two paper clips and a craft knife or blade for cutting out stencils. (Young ones may also need an adult to help with the actual cutting.)

Start by drawing a border or frame of about 13cm × 20cm in the centre of your paper. You will want two pieces of paper, both with this same size of border in the middle of each sheet. One will be cut up into a stencil (number 1) and the other will be for making your master instant picture on (number 2).

Now copy the picture on the right into one frame. Mark this as number 1. This is a simple scene of distant mountains, sailing boats and a shoreline. There's nothing in this which is too hard for a bright person like you.

You can use a rule or straight edge to make the line at the foot of the hills, beyond the lake. This line should be about one third of the way up your paper.

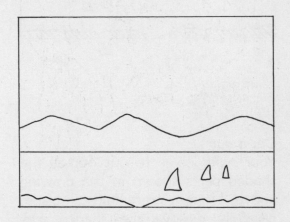

Draw in three sail shapes. The biggest one, of course, should be the one nearest to the foreground. (Artists, by the way, use things in odd numbers — one, three, five and so on — in order to make a good balance or 'composition', as it is known.) Place your sails in the right hand half of your drawing. Notice that the boats are sailing into the picture: this is another good composition idea.

Now shade in your drawing, as I have below.

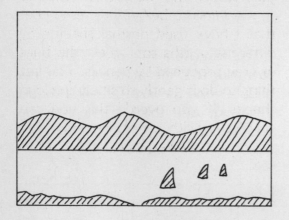

Cut it out

Your next job is to cut out all the shaded parts shown in the drawing above. Using a craft knife or blade, carefully remove the shaded portions. If you are a child, ask an adult to help you. Be sure to cut out on the back of your drawing pad or on a piece of scrap cardboard. We don't want knife marks on the priceless antique table, do we? Worse still, we don't want chopped-off fingers making a mess of our art work!

The paper you finish up with (number 1) is your stencil through which you will rub pencil lead onto paper number 2 to make your first instant picture. I'll explain as we go.

Rub, rub, rub

The next step in this picture-making is to scribble like mad on another piece of paper. Use your 2B and 4B pencils. Keep one area for each. You will need lots of lead, so don't scrimp on the scribble!

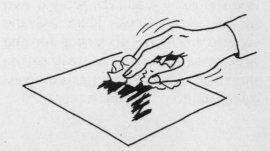

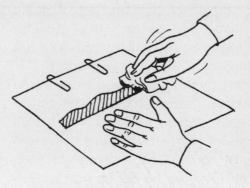

As shown above, attach your stencil (number 1) onto your master paper (number 2) with paper clips. Make sure that the two frames match up. With a screwed up paper towel or tissue, rub the lead of the 2B pencil off the paper where you scribbled.

Now that your paper towel or tissue has a good covering of lead, rub gently — and I mean gently — through your stencil of the mountains. Beginners sometimes make the mistake of rubbing too hard and end up with black hills instead of pale grey ones. Go easy and lift the stencil to see how your picture is progressing. Use the same lead, 2B, for the two smallest sail shapes. Then use the scribble from the 4B pencil for the largest sail, which is nearest to the shoreline. Use the same grade pencil lead again to put in the foreground.

This should be the darkest because it is nearest to the artist: remember this for all pictures. It's common sense, isn't it? What we see closest is always sharper and clearer. Take off your stencil and see how it compares to my version, below, but remember that I have used normal shading by different depths to suggest the hues of grey produced by pencils. The last thing to do is gently to smear in cloud shapes. If you overdo this you can correct it with an eraser. Now, pin your first masterpiece up for all to see!

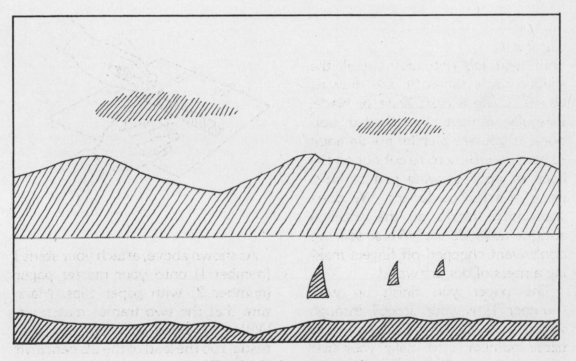

The finished masterpiece!

All shapes and sizes

You can make instant pictures in all sorts of sizes and shapes. You can even make them with coloured pencils, provided the pigment of the pencil doesn't contain wax. I have made quite large landscapes, animal studies and people portraits by using this technique of rubbing the lead or colour into pictures. With a little practice you can make attractive pictures without using stencils, but to start with you will make fewer mistakes by using homemade stencils.

Assignments

1. Make an instant picture of a spray of leaves, such as ivy.
2. Make a bird or animal picture.
3. Invent a landscape picture with hills, sea, boats and a rocky shore.

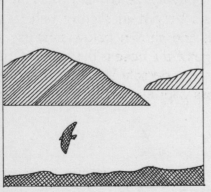

Draw your version of the scene above. Notice which are the pale parts and which are the medium to dark areas. Now make a stencil and your own instant picture.

CHAPTER 2
AN EASY WAY WITH FACES

The human face can be difficult for the novice artist to draw, but there is an easy way that will ensure the right way to start off.

The profile
We shall begin with a face in profile (seen from the side). It will be lightly drawn with a soft pencil held in the normal style with which you write.

First, draw the basic skull shape. This is like an inverted triangle with rounded corners and one side vertical.

Half way down, from the top of the skull to the bottom of the chin, you put in an eye. This can be like a V, but laid sideways and filled in. The eye should be put in slightly behind the front line shown below because the bridge of the nose is beyond it. Check this on yourself by passing a finger across your eye until it hits your nose.

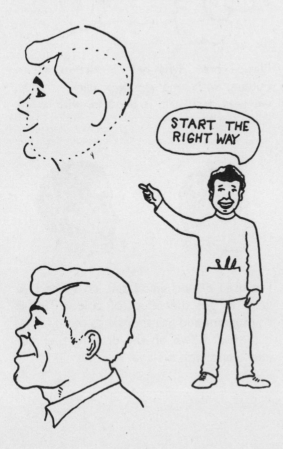

The underside of the nose goes next. As the illustration below shows, this is half way between the eye and the bottom of the chin. It can be a straight line, tilted up, or drooping down — as people's noses sometimes do!

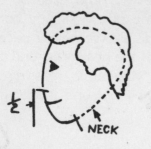

Put the mouth line in after this. This is half way between the bottom of the chin and the nose. The mouth line can be straight or curved up or down. A line that sweeps up, as you may know, denotes happiness. Why not start with a happy face?

Your sketch should now show the correct proportions for a face, with nose and mouth in the proper places.

Hair
Put in the hair line, as shown, by drawing just the outline of where the hair goes on the face and above the skull. If you're drawing a bald man, you won't have this problem. At this stage, it isn't necessary to try and draw each hair, as some beginners do. One of the most clever techniques used by artists is to suggest things using as few lines as possible.

Ask yourself if the hair is wavy, straight, fuzzy or whatever, then jot it down.

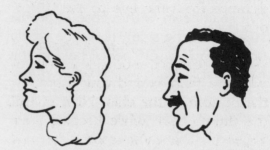

Notice how light hair is drawn as an outline, with one or two dark strands, whereas dark hair is filled in, with a few areas left blank.

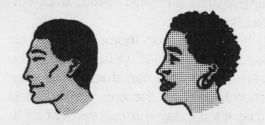

I've used a mechanical tint on these two faces to get the effect of colour. This is transparent and has thousands of tiny dots. It is stuck down on the drawing then cut into shape with a blade.

14

Be a people watcher
Try to get into the good habit of looking at people you meet and mentally drawing them. Later on you will be able to draw them when they have gone, or quickly sketch them from life.

Ear, ear
Before we put in details, we must draw the ear in the right place. This is done by measuring the distance from the outside corner of the eye to the bottom of the chin; this equals the distance from the eye to the BACK of the ear.

To test this for yourself, place an index finger on the outside corner of your eye then extend your thumb to the bottom of the chin. Now swivel the thumb back while keeping your finger on the same spot. This will bring your thumb to the back of your ear. This is a guide to where to put the ear in your drawing. If it isn't exactly right, don't worry about it because we all vary in small degrees, and there's a million combinations to faces.

If you place an index finger on an outside corner of your mouth, the same side as the ear, then swivel your thumb back to the ear, you will find that it's the same measurement as in the previous exercise. When doing these tests relax your finger and thumb naturally.

Draw in the ear, but don't bother too much about the inside structure. Getting this accurate will come later.

Noses
You can next start to build the face by joining up the end of the nose to the forehead, and remembering to indent for the bridge of the nose. Feel your own, just to check, or use a mirror as an aid. The line of the nose can be hooked, droopy, broken, narrow, long or short depending on your subject. You may decide to draw it straight to begin with.

Eyebrows and things
Above the eye, put in an eyebrow. This can be thin, bushy, arched, straight or barely visible.

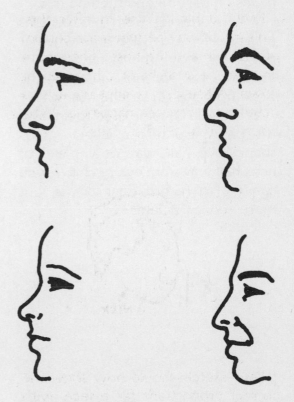

There are many different shapes and types of eyebrows. Here are just a few.

If the face you are drawing has age lines, bags under the eyes, war wounds, dimples, or other marks, draw these in lightly. Now clean up your picture with an eraser. Haven't you done well?

Now for the neck lines. This causes some folk bother because they don't realise that the neck comes out of the chest at an angle of about 15° and juts into the skull. It is not straight up from the body. Hold a pencil by the tip so it is pointed vertically up, then tilt it to one side about 15° — this will give you the angle to follow when you add a neck to your drawing. Have another careful look at the heads on page 14 and then do this.

When drawing from photographs or from life, you will notice whether necks are long, short, fat, thin, or scrawny, but for now just get the slope from the rib cage about right.

When you become used to drawing the basic structure quickly — skull shape, eye half way down, end of nose half way from eye to chin — you can try to record finer points, but more about this later.

The full frontal face

To draw a face from the front, imagine it as an egg. Draw an egg shape with the pointed end at the bottom, then, very lightly, draw in a line down the middle, and one across half way.

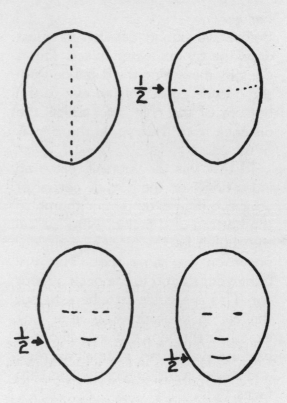

Notice that the half way points for the eyes, underside of the nose, and the mouth are just the same as in your profile drawing, so the main difference is the egg shape, as opposed to the skull outline of your last drawing. Put in the eyes, end of nose and mouth, as shown above.

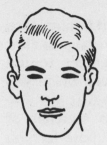 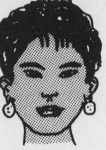

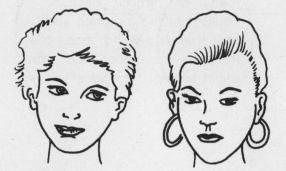

As you master these first basic structures and draw quicker, you should try to sketch faces that are turned to one side. The way to do this is to remind yourself of the egg shape, and begin by drawing it so, then lightly put in dotted lines in curves, as they would appear if you did them on a real egg. To check, draw them on the hard boiled one you are going to have for breakfast!

Use an egg
An egg with bits of plasticine stuck on for the nose, ears and chin is an excellent model on which to practise.

Look at the pictures above, and then develop your drawing by adding ears. These, you will see, look slightly different from the front. The top of the ear, generally, is in line with the eyes, and the bottom is level with the bottom of the nose. When drawing from life, ask yourself if the ears stick out, are close to the head, are long, short, or have an edge which protrudes. Draw in the ears, then draw in the hairline as you did for the profile. The drawings above also show different hairstyles, lips, mouths and other parts. Draw in the missing pieces then erase the lines you don't want. Select your best effort and have a go at inking it in with a fibre-tipped pen. When this is dry, rub out the remaining pencil marks and pat yourself on the back — I'm sure you deserve it!

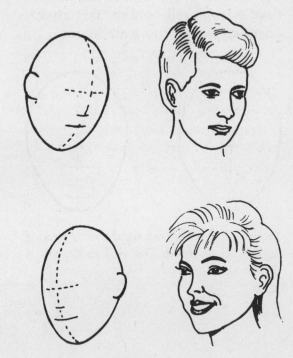

Try to mould plasticine like a face, chosen from these drawings. Then, with or without the help of an egg, try to draw these faces then ink in the best. Erase pencil marks and give yourself another pat.

17

You won't be able to model details like eyebrows or hair using plasticine, but even a rough job will give you a good idea of how a face is constructed and will help you to sketch faces.

Lots of looking

It is important to spend more time, at first, looking at your subject than on the actual drawing. Most people, when asked to draw something, immediately begin before giving themselves a chance to observe their subject properly. To do this is to make the job harder, so look well before starting.

With practice, you should be able to copy all the faces in this chapter, and have enough self-confidence to move on to something more ambitious.

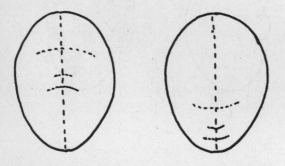

You may like to draw a head that is looking slightly up or down. The way to do this is shown above.

Assignments

1. Draw the profile and frontal face of four people from magazines or newspapers; remember to use the same basic rules which you have now learned.

2. Try to draw two sketches of someone who will pose for you for two or three minutes. If you live alone, attempt a self-portrait. Vincent Van Gogh did many of himself because he couldn't afford a model, and had few friends around, poor chap. In years to come your effort might be worth millions!

CHAPTER 3
HOW TO MAKE IT SIMPLE

No matter how good an artist is, if the drawing is started off with the wrong basic shape it will always be wrong and look so. As a simple example, if a square barn is sketched and the first drawing shows it as being oblong with rounded corners then all the attention to details and correct shading will have no effect because it's not the right shape. In the same way, if you want to draw a stocky, short person and you begin with a tall, thin one, the finished picture can never be right.

Look first
This chapter is devoted to keeping our drawings as simple as possible. To try and do fine, detailed art while learning to draw is very difficult and awfully confusing. If your attempts are more basic than the examples shown, then that's fine.

We start off the right way by simply looking at our subject and mentally noting the rough shape which we can jot down in pencil. We can use the same pencil, held at arm's length, to decide if a thing is upright or sloping, and to gain an impression of size. You should close one eye when doing this. A pencil can give you an idea of how lines are — if they are curved, irregular, or more or less straight — and is particularly useful when drawing perspective.

Stick people
A help in drawing people is to begin with a stick person, then thicken it until it's something like the real thing. If you sketch a man wearing a suit, you could put down a square for this with the head, legs and shoes added.

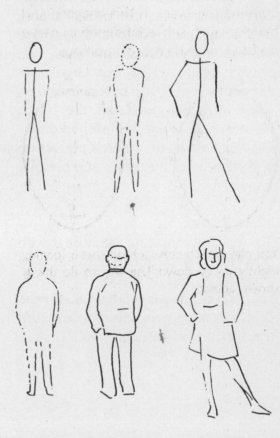

Have a look at these sticky examples above. And then copy them for yourself.

19

Most beginners avoid drawing stick people because they feel that it's a sign of being unable to draw. Of course it is! So what? If a method of learning works for you, "stick" to it!

Remember that the human head is about one seventh of the total length of the body. Do several quick sketches until it looks right. If your natural style is that of a cartoonist, you won't have this problem because this art form allows the greatest freedom, and it isn't necessary to keep to life-like proportions, but most of us have to learn to draw properly before we can turn our subjects into cartoons. There will be more about this fun subject later in the book.

To get it right first time involves careful looking at the overall shape, or shapes, and putting it down more or less right. Small mistakes can always be put right, but large ones almost never. This is particularly true when drawing people. If the basics are accurate, then the finished drawing can be fiddled towards perfection with the aid of an eraser and pencil.

Make it quick

Try to draw quickly because to go slowly is to make more mistakes than necessary, and to cause hesitation. Fast, spontaneous work is usually the best, because your inbuilt computer, the subconscious, helps you.

Tricks of the trade

Before we spread our artistic wings on different subjects, we need to know a little about how to get certain effects, a few tricks of the trade with pencil or pen. The most common method is shading and it is an essential part of drawing.

Study and copy the examples of shading shown above. You will be using these often throughout the book.

Most forms of shading are done by simple strokes which may be vertical, diagonal, curved or haphazard. When lines are crossed over, this is called cross hatching, and it is very useful for depicting deep shadow, or dense patches.

Putting shading into practice

I will explain fully how to draw trees, landscapes and animals later on in the book, but for now I want you to make a start on using some shading techniques on a few simple drawings.

A tree

There are a lot fewer trees around us now than there were a hundred years ago, but fortunately beautiful trees of all sorts of shapes, sizes and leaf textures are around us still wherever we go. Perhaps you can look out of your window and see one right now? If not, get your coat on and pop down to the nearest public garden or park and see how many different types you can spot on the way.

Many beginner artists, particularly children, find it difficult to draw trees. As always, this is due to not *looking* properly. The key to drawing trees is to *keep it simple* and make use of shading to show the texture of the tree bark and the shadows.

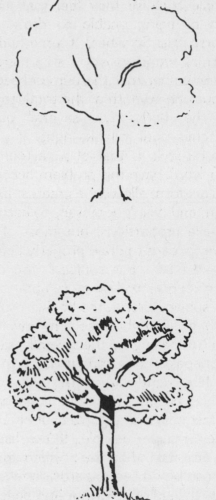

Try sketching the tree above. Jot down the rough basic shape first with thin, broken lines in pencil. Next add the small areas of shadow in the leaves and branches, and dark, dense splashes of deep shadow on the trunk. Do this by blocking in. Leaves are suggested by a few squiggly lines here and there. Finish off with a line or two on the trunk, and a bit of cross hatching at the base to represent grass. Wasn't that easy, and fast? If your answer is no, go and do all the washing up as punishment for thinking negatively!

Landscape

Now move on to an easy landscape. Recently, a scene caught my attention when driving towards Northampton. There was a build up of thunder clouds during a sunny day, and the sloping field, trees and lovely old wooden fence appealed to me. The car was parked and the drawing done in about twelve minutes. You may have twice this time.

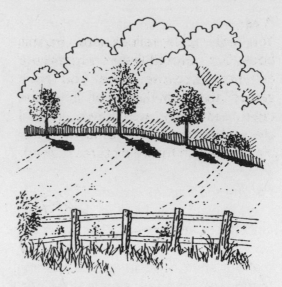

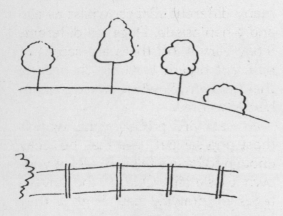

Start by putting down the slanting line of the field, the basic shapes of the trees, and the fence posts. Use close, quick strokes to get the effect of the dark line of the distant hedge, the tree shadows on the ground, and the dark parts of the trees. Notice that one side is lighter as it faces the sun. Put in shading on the posts, and the tractor furrows in the meadow. The grass in the foreground is shown as open cross hatching and a few dots and strokes suggest wild plants sticking up beyond the fence. The bush in front of the fence is again done by close squiggly lines and a dot or two. Draw the outline of the clouds by using thin, broken lines and curly ones. Put in shading by diagonal lines and your picture is completed.

When out walking, or driving, you might like to try another easy scene like this, and do it in just the same way. If you have a large garden you have a subject that could provide many pictures. The more you draw the better you get!

A cat
You will tackle felines later in this book, but I would like you to draw a cat now because once you have gained the knowledge of how the head and body are drawn, it will always be very similar for all moggies, big or small, in future pictures tackled.

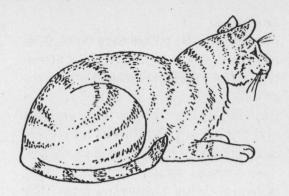

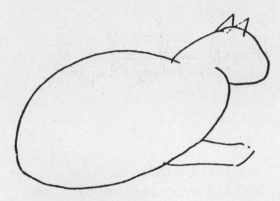

Begin by copying the basic shape of a cat, as shown. Do the head next and note that a cat's nose is short, ears and eyes large, the forehead pronounced, and that they are always smiling! See the curved up line of the mouth. A sitting cat presents an easy, rounded shape. The fur is suggested by fine shading, but these lines must run the same way as the fur grows on the real cat. Put the whiskers in with thin, delicate lines and that's another masterpiece finished!

Cats are a great subject and offer many different shapes, whilst awake and when asleep. Dogs are different. They vary a lot: there are scores of different breeds with big changes in their anatomy, which makes them harder to draw.

As cats are probably the world's most popular pet, you may be lucky enough to have a feline model of your own to sketch. One of the advantages of drawing cats is that they spend the majority of their day asleep, and so are quite likely to sit or lie still while you sketch away. If you don't have a cat of your own, I'm sure that you can find a friend or neighbour willing to let you immortalise their feline companion. Or perhaps you could visit a local animal sanctuary for poor abandoned moggies and ask to draw their tenants. You never know, you might come home with a new friend!

23

People

You should try drawing people now. Don't bother with detail at this stage — go for a fast, accurate sketch.

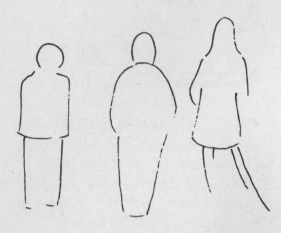

Have a shot at these people. Begin by having a good look, as usual, then jot down the basic shape. Fill in the outline by quick, simple lines, and you have progressed further. If you are feeling confident, the best thing, of course, is to try and draw everything from life, but otherwise plod along with copying for the moment.

Assignments

1. Draw two different trees from life, using the technique you have just tried.
2. Draw a cat sitting, or walking, with the same method.
3. Draw, from life, two people as simple sketches.
4. Draw an easy country or park scene.

CHAPTER 4
WHAT A FACE!

We are going to do more with human faces in this chapter and, of course, base all our sketches on the right structure taught in Chapter 2.

Faces everywhere

Though you may live on your own, you need never be short of models to draw. To prove this point, all the faces on this page and the next were drawn from just two daily newspapers and a mail order catalogue. There are famous people and unknown ones, all very interesting for the artist.

Newspapers use cheap paper that doesn't allow too much definition as compared with a glossy magazine, but this can be an advantage when learning to draw. Have a close look at some of the examples below and see how little detail has been drawn: eyes may be simply blocked in, mouths expressed as a single line, and hair just suggested. When copying these pictures, begin by drawing the basic egg-like shape or the skull profile, using the dotted line technique as before. When you are satisfied with the result, rub out the pencil marks, then ink in.

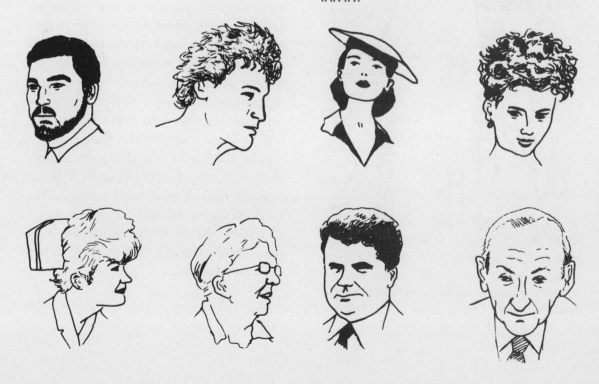

Test the method by putting tracing paper over the examples below. Draw on it the dotted lines for each face, then complete the drawing as seen through the tracing paper.

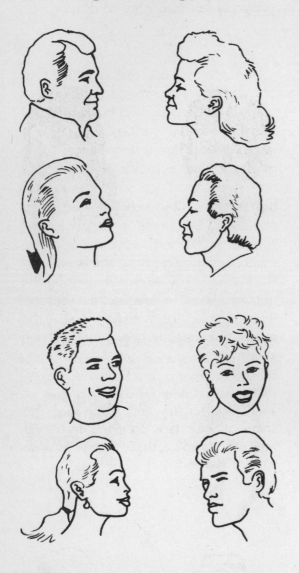

A good tip about drawing teeth is not to draw them! Notice how teeth are suggested by a blank space. This is the most effective way of doing them, unless you are drawing a large poster advertising toothpaste or tooth care!

You're looking good

A good way of learning how to get expressions right is to use yourself as a model. Use a large mirror and do a bit of acting: grin, scowl, look angry, haughty, shocked, or whatever you fancy! Have a close look at what your eyebrows, mouth and eyes do. Study your striking film star profile by using more than one mirror. It's all there for you to see.

If, like Van Gogh, you use yourself as your own model, don't be put off by mistakes or be tempted to flatter yourself too much. Should you go slightly unhinged, please don't hack off an ear or do anything so drastic — enjoy your madness, just like I do!

Models

If you live with a group, spouse, friend or family, turn on your undoubted charm and ask someone to pose for you for a few minutes. Get into the habit of looking longer than drawing, and this will help you and prevent your model from freezing, or getting bored with one pose.

You could use your worst enemy as a model, or folk you don't know, but try to draw them when they are not aware that you are doing it, otherwise you could end up with a black eye, or ruined picture. I must admit to drawing hideously funny cartoons of the people who sometimes annoy me. Watch out if there is an irritated cartoonist about!

Expressions

Another aid to learning how to get expressions right is to draw cartoon faces. You could copy some or you could convert life sketches into cartoons. This is explained further in Chapter 16. A scan through daily papers is useful to learn from the cartoons and photographs how faces are shown.

Photographs are useful to all artists, and particularly to beginners. Copy as many as you can, trace a few, break them down into simple line sketches and you will make rapid progress learning how to draw.

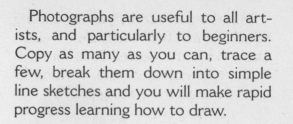

 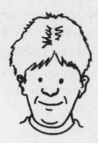

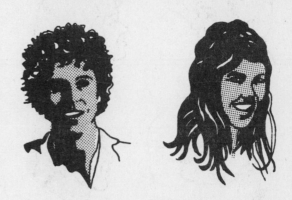

If you feel like being a little more ambitious, try drawing these faces. Notice how a face can be blocked on one side, as if in shadow (as above), or shaded with diagonal or horizontal lines (as below) to give yet another effect. Try both techniques with some of your face drawings. Begin with light pencil strokes, then ink them in when you are satisfied.

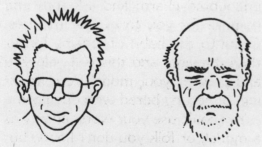

TRY CARTOONING

Look closely at the cartoons above, then have a go at them yourself.

Practise drawing faces from different angles and of different races, as below.

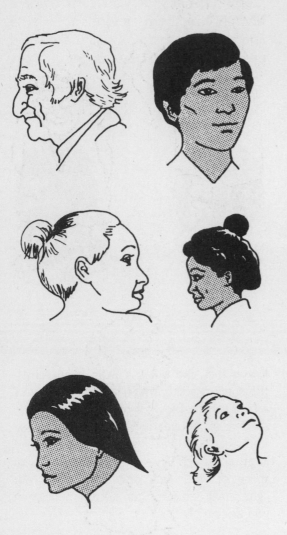

Later on you might try drawing straight off with ink, as this seems to intensify concentration and, surprisingly, tends to cut down on mistakes, so increasing self-confidence.

To re-cap on earlier pages, do not attempt fine, detailed work at this stage — unless you happen to be one of the world's undiscovered geniuses. This book is written for the raw beginner who just wants to be able to jot down, simply and accurately, what is seen.

Many of us live in towns or cities and we are surrounded by thousands of models. Once courage has been plucked up, we can go out to draw from life and there is no shortage of faces or bodies to practise on. A trick to use when drawing folk is the one already mentioned — try to sketch when the victim is unaware of what you're up to. Look for long spells, then draw quickly, and never worry about mistakes — these will disappear as you progress. Forget about getting a facial likeness at first, this will come the more that you draw and, very likely, faster than expected.

Where to go
Corner seats in busy cafés, bars, tea rooms, libraries, art galleries and many other places are good vantage points to work from.

People are usually interested and friendly towards a working artist, so never be put off by crowds. Once, when drawing abroad, I went into an almost deserted coffee bar because I had spotted and heard a screaming parrot which was crammed into a small cage. I ordered a drink then started to do a very detailed pencil drawing of the poor bird. As time went by I noticed that the bar manager's face grew longer and longer, for no apparent reason. After a spell, I had the impression of being watched, and turned round to see a large policeman standing behind me. He held his massive arms across the doorway to prevent customers from entering in case they disturbed me! He smiled widely at me, but I felt divided by embarrassment and gratitude. I

finished the picture rapidly, gave it to the gloomy man behind the bar, and charged off into the bright sunlight. Funny things sometimes happen to us artists!

There is a slight difference in technique between drawing male and female faces. Men tend to have rugged, beaten up looking mugs, whilst ladies are much more delicate, smooth and gentle. It pays to use thinner lines when working on a woman's face (or a child's), but heavier lines go more with a man's face. If you are using a pencil, make the point sharp for girls and blunt for men! I prefer to draw most originals on tracing paper because it has a very slick surface and feels nice to work on. You may find that ordinary typing paper is pleasant to draw on. It's worth trying several pens and papers just to find the one you like best.

You could even draw from the top of a shaking, bouncy bus. The wavy lines produced from this actually add to funny cartoon drawings, as above.

Children

To start with you may find that children's faces are hard to draw, there being no age lines, heavy bags under the eyes, or distinctive jaw bones. Children have larger heads, in proportion to their bodies, than adults. This is because a baby is born with a relatively big head. During childhood, the head grows much more slowly than other parts of the human body.

Have a good look at these drawings of children before copying them. See how round the faces are, and what is suggested by just a few lines.

Assignments

1. Take two newspapers then draw ten faces from them. Trace the first four only — do the other six freehand.
2. Use a glossy magazine to repeat the above exercise.
3. Draw, from life, four faces.
4. Ink in your best work and date all pictures.

CHAPTER 5
HANDS AND FEET

Hands, for the newcomer to art, are probably the most difficult part of human anatomy to draw accurately. So we shall start at the other end, by having a look at feet first. To make it easy, we will begin by sketching old boots. If you don't possess a pair, make do with a glass slipper, or the latest thing in man-made plastic!

Footwear
Drawing different footwear is first-class practice, and good grounding before moving on to bare feet and hands. Have a long, careful look then put down the basic shape. Men's shoes, seen from the side, are usually wedge shaped, but women's shoes vary enormously; they can be flat-soled, high heeled, pointed, square, cut away, or have many variations.

Sketching footwear is interesting, with so many models around which we see daily. If you are unable to get about much, you might care to use your friends as models. Just tell them you are going to record their tatty old boots for posterity, or want a study for a book. This never fails!

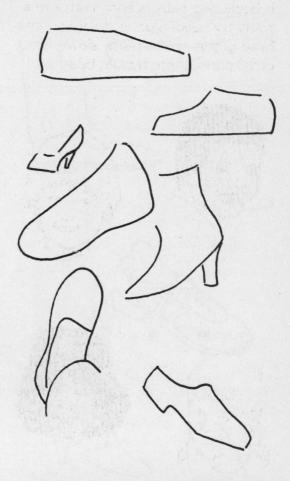

It will help you if you can draw as many different pairs of footwear as you can, and from different angles. Start with your own: a mirror could come in useful here because you can see your feet from different angles. Try to do quick ink sketches similar to those shown in the examples.

The drawing of a worn slipper, bottom left, is a bird's eye view. We see part of a wrinkled, decrepit sock. This is my own hoof! Try drawing all these varied styles of footwear, then have a go at your own.

Feet

Now try to draw bare feet. Again, you can use your own or those of friends, and a mirror, or a combination of all three. Feet are basically the same shape, but there is one thing that is different. What is that? Toes vary with almost every individual: they can be thin, fat, long, short or crowded — ask any lady who habitually wears pointed shoes!

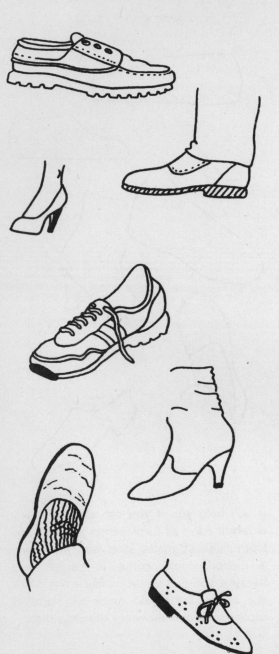

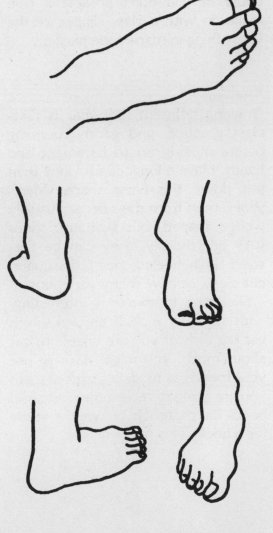

Try drawing bare feet from different angles.

The human foot is a wonderful structure of 26 bones, arranged in arches to absorb shock and carry great weight. Most of us come into this world with a perfect pair but, due to poor footwear when young, and bad walking habits when older, we end up with an imperfect pair. Don't expect to draw a text book example. You should see mine!

Think of toes as being like very small fingers, with the big one resembling a thumb. If you are able to draw from life, notice how ankle bones jut out just above the foot.

Hands

Unlike feet, the hands which we normally see are bare. Like the foot, the hand is another wonderful engineering job of small, braced bones which are very strong, yet allow much movement and dexterity.

A hand laid flat is not, in fact, flat. It's slightly rounded. Remember that hands contain many subtle curves. It is helpful to think of the shape as being like a mitten. Just a thumb and a sock to put the hand in. So, when you look at a hand, no matter what position it's in, imagine it as a mitten.

Try drawing your left hand, if you are right handed, or right one if not. This is good practice and you can change the shape or gesture in order to do many drawings. Here, once more, your chums could come in useful. Spin a tale about immortalising them for their beauty.

The illustration below shows that knuckles and joints are on a curved line. It is important to draw them this way, otherwise what you put down will look flat.

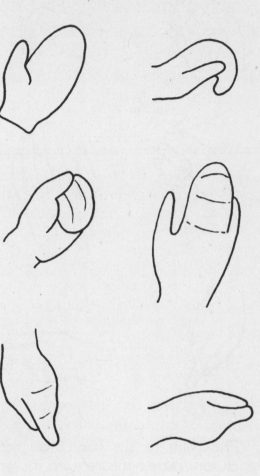

Here are just some of the many positions in which you can immortalise your non-drawing hand, or that of a willing model.

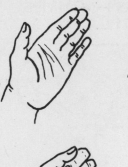
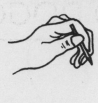
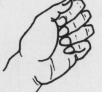
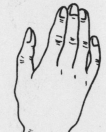

There is quite a difference, usually, between the rough, hairy paw of a man, and the delicate, smooth hand of a lady, as shown below.

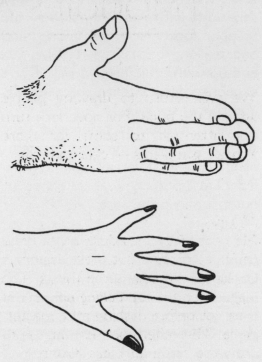

The palm of the hand, and the back, are rather square with thumb and fingers stuck on the end like slim, or fat, fish fingers. There is a large pad of muscle from the base of the thumb which rises across the bottom of the palm. There is a change of shape where the hand joins the wrist. This is often marked with wrinkles. Have a look at your own.

To give you an idea of how the hand is curved, you might try putting a coloured chalk line across the joints and knuckles. If you try this, don't use permanent colour paint, as I did!

Assignments
1. Draw two pages of footwear, of both sexes, then two pages of bare feet.
2. Draw two pages of hands, of both sexes, belonging to people of different ages.

CHAPTER 6
MOGGIES AND DOGGIES

We will return to drawing people later in the book. For now, let's turn our attention to some far more appealing subjects — cats and dogs.

Moggies

Many children and adults try to draw their pet moggy. But most beginners go astray with the same things. The biggest fault is *not looking properly* at their cat before dashing off a masterpiece. The other common fault is to draw the hind (rear) legs wrong.

Most four-legged animals have the same kind of shape to the upper part (thigh) of their back legs. Once you have fixed the basic shape in your mind you should have no further trouble in drawing all kinds of animal leg. With a little practice you can learn to look at a moving animal then draw it quickly. The trick is to notice how it is put together. You want to know what the head, body, tail and legs are like. Then you stop looking at your subject and make a fast sketch of what you have seen. When this is correct you go back for a second, third or fourth look to see the details of feet, claws, eyes, ears and so on. This may seem hard at first but it becomes easy when you have fixed the form or shape of an animal in your mind.

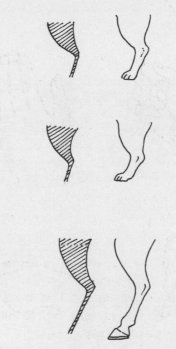

The hind legs of a cat (top), a dog (middle) and a horse (bottom). The basic shape is very much the same. I have shaded in the big thigh muscle shape (left hand drawing) which is drawn as two curved lines going the same way. This large muscle tapers into the lower leg in the same way as our own thigh goes into the knee, shin and foot.

Start the right way

Start by making copies of drawings or pictures of cats. These won't move! Copying will train your observation and make your drawing accurate.

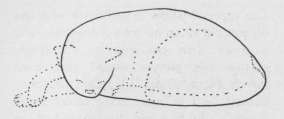

You may have noticed that a cat seems to enjoy washing itself. Its eyes close and a look of happiness appears on its contented little face. Is this what you look like at your morning scrub? My moggy was on cloud nine as she washed her face. Copy my drawing of her below, starting in the usual way.

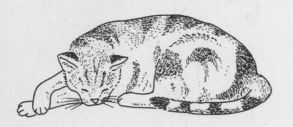

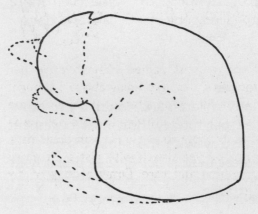

A sketch of my last moggy is above. She was dozing on a window sill. Cats spend most of their lives asleep. This is to save their energy for hunting or scrounging around humans for food.

Notice that her eyes are closed and are positioned over halfway down the head. The nose is quite small and ears large. She has a smooth coat. All cats are built pretty much the same. If you can make a good sketch of one then you will be able to draw all cats, big, small, spotted and striped.

Draw the basic shape (bold lines) of my cat then carefully add the details (dotted lines). She was a tortoiseshell cat. Her soft coat was orange, brown, black, white and fawn. I have tried to show this by tiny lines which run the same way as her fur grew. This is important. It makes the sketch look real. Also, the shading of small lines and dots helps to reveal her shape. It's a mistake to put in all the hair. I just popped in a bit here and there.

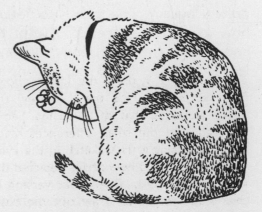

Cats corrected

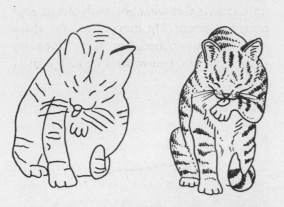

A young artist named Hannah drew her version of a cat grooming above. I thought it was a very good attempt at capturing the blissful look. My drawing (on the right) was done to show you how Hannah could have improved her sketch with just a bit more know-how and care. Draw a copy of my illustration.

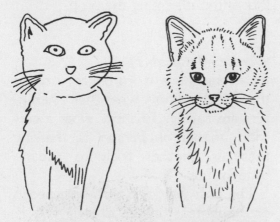

Lorraine, aged 9, drew the kitten above. This was also a nice try. I re-drew the kitten alongside that of Lorraine's. See if you can spot the small differences made from the young artist's sketch in the eyes, whiskers, ears and how I have depicted the fine hair of a kitten. Draw your version of this. Don't forget to draw out the basic shape first.

The 'top cat' below is by Patrick who was 8 years old when he drew it. He drew with a pencil then coloured it with bright orange. His picture would have been slightly better if the leg shapes had been correct, and a little more attention to details in the face and the position of the tail. Look at my sketch below Patrick's, then copy it.

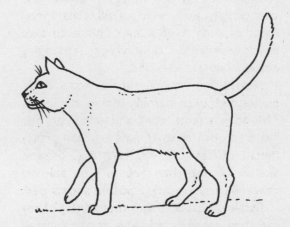

Crazy cats

There are many famous cartoon cats. We see them in newspapers, magazines, on TV and in films. If you can invent a new cartoon cat which the public like, you could become rich and famous. Wouldn't that be brilliant?

You might be a natural cartoonist

MUM DAD

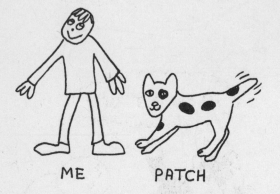

ME PATCH

These super cartoons were drawn by a group of infants, asked to draw their family.

Cartoons are high up on the list of what children — and adults — like to draw. This doesn't surprise me because cartoons are fun to draw and look at. I have used them in every book that I have written.

Many infants who begin to draw are natural cartoonists, even though they may not intend their sketch to be funny to look at. This is because they haven't been taught how to draw, so they do it their way. This results in wonderful stuff. The highest form of cartoon is to have a natural style which people find amusing to look at.

Cartoon animals can walk about on two legs, wear clothes and do anything a human can. Or they can be life-like with the ability to think or talk as we do. You have lots of freedom as a cartoonist, so you can have lots of fun dreaming them up.

Words and thoughts
Cartoonists use word balloons to let their readers know what their characters are saying. To show what a cartoon animal or person is thinking there is another trick to use: a thought bubble.

The best way of portraying speech or thoughts is first to draw lightly in pencil a straight line and then put the words on this. When you have done this, you enclose the words with either a balloon or a bubble. That's easy enough, isn't it? When the ink is completely dry, rub out the pencil lines.

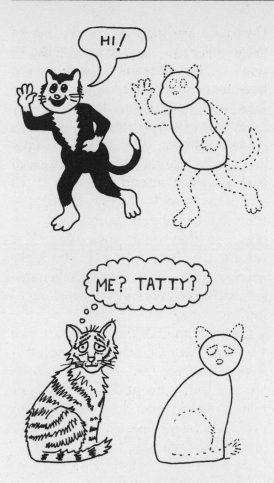

Notice how I have drawn three-fingered hands and three-toed feet on the cartoon cats below. Anything goes in cartoons, so long as people can recognise what it is that has been drawn. Copy these cartoons for yourself, but try to think up different words for the speech balloon and thought bubble.

Here are ideas for ways to use word balloons and thought bubbles. Notice how a word balloon is drawn to appear from the character's mouth. A thought bubble, however, is shown as rising in tiny bubbles from the cartoon cat's head.

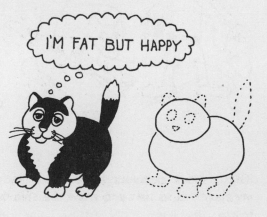

39

Doggies

Most dogs make lovely pets. All a dog seems to want is to be with its owner. I have seen lots of dog drawings by children and adults. The same faults crop up to spoil many a good sketch, as in cat pictures. You, however, have already learnt how to avoid these mistakes by taking a proper look at your pet, then drawing the shape accurately.

Let sleeping dogs lie

Dogs who are asleep lie still for a spell, so this is when to draw them from life. I made an especially fast sketch of my favourite dog, Polly. She was on the verge of trotting off to dreamland when she decided to take a squint at me in case there was any food on offer.

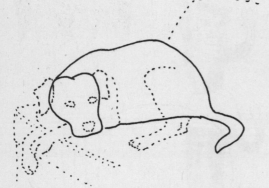

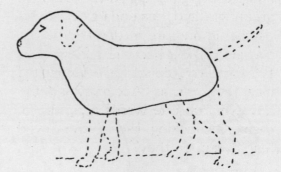

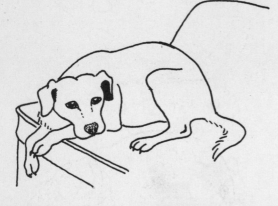

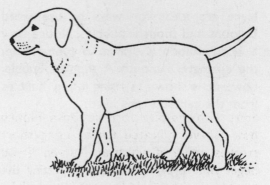

Polly is black in colour, but I didn't shade my sketch in so that you would be able to follow the lines more easily. Copy my illustration by first putting down the basic head and body shape (bold lines) then carefully draw in the missing parts (dotted line). Remember to rub out any unwanted lines.

Labrador Retrievers are usually friendly dogs — they are the UK's most popular pooch! See how you cope with drawing the one above. Notice how grass has been suggested by using short pen strokes that go up, the same way as grass grows!

A mistake that many beginners make is to draw all four legs on the same level. Although they probably are level, we don't see them like this because the legs which are furthest away from us appear to be shorter. This is called perspective. It's the way the human eye sees things. It affects all drawings. There will be more about this in Chapter 13.

Pet portraits

Animal portraits are often used on greetings cards, calendars, in advertisements and are in demand by pet owners. If you become good at this art form you could have yourself a nice little earner. Accuracy is vital, however; no-one wants a picture of their pet looking like a cross-eyed hairy lump, do they?

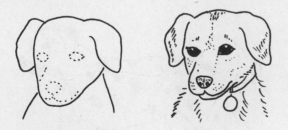

Start with the pup portrait above. Notice how I have indicated fur by using short strokes, some of which are curved. If you begin your drawing accurately, getting the head form right (bold lines) the rest will be quite easy to do. Off you go!

Now try a slightly more advanced portrait after examining the illustration on the right. The basic form of the head is quite easy. Take note of the bold lines. The fine shading can be put in with a sharp-pointed pencil. Take care when drawing the eyes; leave a white spot in the pupil.

The illustration below is of a Yorkshire Terrier, or Yorkie, as they are often known. See how the long hair has been drawn in ragged clumps which sprout up from each side of the head and face. Yorkies are happy, lively little fellows. I once upset an owner of one of these jolly animals by suggesting that her pet would be ideal to clean car windows with. Some people have no sense of humour!

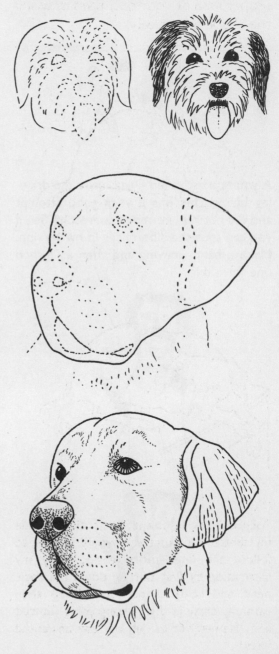

Corrected canines

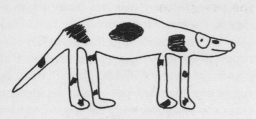

The upper drawing on the left is an accurate copy of a sketch of a dog drawn by a young artist named Biddy. My version of the same pooch is the lower sketch. Biddy's dog was well drawn, with good, bold lines. It just needed more careful observation and correct drawing of the legs, body shape and neck. See if you can work out a basic shape for my corrected dog and then draw it.

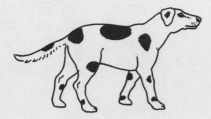

A young artist called Duza made the drawing below. This was a very good attempt and did not require much correcting. See if you can spot the differences in my version. Make a basic drawing and then a finished one from this.

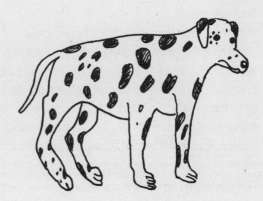

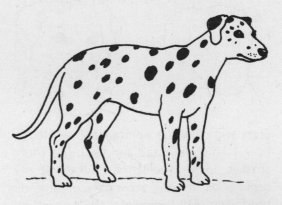

A youngster named Jack, aged eight, made the original sketch which I have used above. Jack had observed the dog quite well, but had slipped up on drawing one back leg and the paws. See how I have corrected these mistakes. If an artist checks what has been done, little errors can be put right quickly. Always check your work.

Dotty dogs

Fancy a bit of fun inventing cartoon dogs? Good. If you come up with something like the world-famous Snoopy you could end up as a million-aire (in which case I would be round to your house like a flash of lightning!).

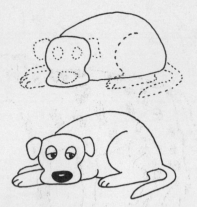

Polly was made into a cartoon, above. See how simple this is to draw, with no details of fur? I just made her ears and nose larger than life.

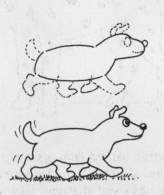

This little dog trotting along is another simply-drawn cartoon. Notice how movement is suggested by making tiny curved lines. Cartoonists call these action lines. They are very useful. Draw yourself a happy little dog based on what I have done.

Study this cartoon below and then draw your version of a talking dog who is saying something witty.

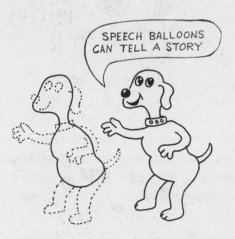

Cartoon animals, dogs, cats, tigers or whatever, can get about on two legs and behave like humans if that's what the artist wants. Speech and word balloons or thought bubbles come in handy for telling a tale or making a joke.

Assignments

1. Draw a sleeping cat from life or from a photograph.
2. Invent a cartoon cat, thinking or saying something funny.
3. Draw a dog from life and from a photograph.
4. Invent a cartoon which shows two dogs talking.

CHAPTER 7
ANIMAL MAGIC

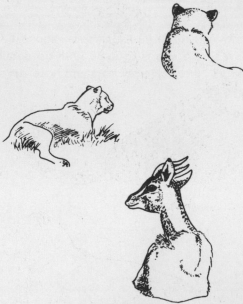

There's magic in a fine animal drawing. This chapter explores the right way to become a wildlife artist. The first essential, of course, is to have a good and accurate look at your subject before starting to put it down on paper. This is particularly true when your model is on the move or a long way from you.

I always try quickly to jot down the head and body shape first then follow with the legs and tail. If this is done correctly it doesn't matter if the creature moves about because it's easy to note the details of eyes, nose, fur, markings, etc., but if the basic shape is wrong, nothing will make the finished picture look right.

Though I'm able to draw straight off with a pen, I have mentally recorded the general size and shape of the animal. If you work the same way, don't bother about mistakes — these will begin to disappear as you progress, or rather as your looking improves.

Where to go
Zoos, wildlife parks and museums — where your model keeps still — are good places for a wide range of subjects. I've spent many hundreds of happy hours in these places just watching and drawing.

Note the simple style of these drawings and the fact that most of the animals were resting, or in still poses. It's very often worthwhile waiting until an animal settles, but always be prepared for it to move, so get it right fast and you will have little trouble.

44

It is possible to draw from TV wildlife programmes when the camera shots are just 3 or 4 seconds long, and even easier if you have a video or DVD which can be paused. What you need to do is memorise the shape and see it in your mind's eye, then draw it quickly. You can then take your time putting in details and markings.

An elephant is considered hard to draw accurately, so it's important to get the basic parts right. Try sketching egg shapes for head and body, the blunt end at the rear. Then put in the thick legs with guide lines. Notice how the wrinkles are drawn in the finished picture, and shading used to give depth. Remember to jot down the trunk wrinkles, bags under the eye and sweeping tusks which are adapted canine teeth.

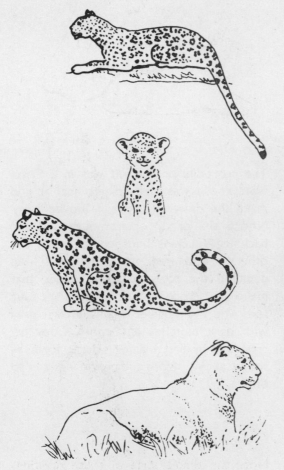

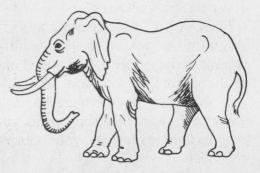

Have a go at drawing or tracing these examples.

This is an African elephant, so it has huge ears and a sloping forehead. Take note of the head and body shape before drawing your version.

Reptiles

Crocodiles have been around since the days of the dinosaur. These deadly creatures haven't changed much in millions of years and kill more people each year than snakes, big cats or elephants.

What would you do if you were chased by a crocodile? You don't know? As you are such a good student, I'll tell you what you should do. Shin up a tree fast. If there isn't a tree nearby, run like mad, but in a zigzag line. A croc can run faster than you in a straight line, but has to slow up to turn. Next time you meet one on your way to the shops you will now know what to do!

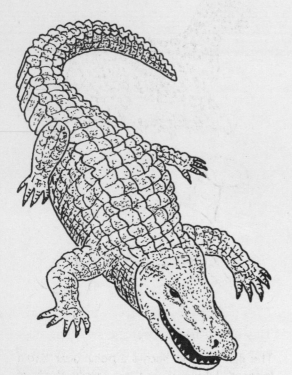

The crocodile on the left was in a Cotswold zoo. I was able to get near it and make the drawing before it moved away. Notice the partly open mouth and the back leg which is bunched up while the others are splayed out. See how I have depicted the rows of tough scales that make up a crocodile's skin. There are four toes and five fingers. It was brown grey with dark blotches and spots. Copy my crocodile by first making a basic form, as shown above, before adding the legs and so on.

The python below was drawn from life in a zoo. It was easy to draw as it lay coiled up behind a thick glass plate. It had a pale skin with red brown patches and a purple forked tongue.

Polar bear and leopard

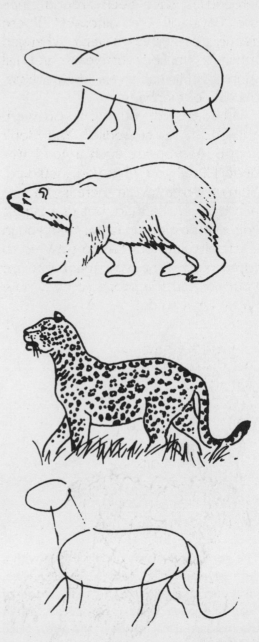

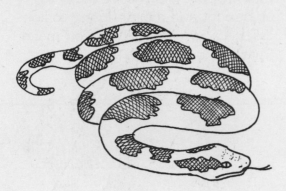

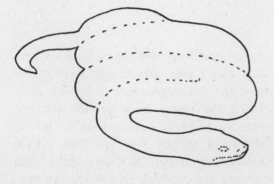

The figure above shows a polar bear and a leopard. I love all the cat family. Both of these subjects were sketched from TV programmes in seconds, but the spots and fur details were put in afterwards. This trick can also be done with human animals on the box.

A gorilla

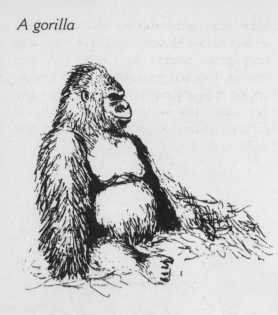

The gorilla above was rapidly drawn with a type of pen which gives a very fine line, ideal for straggly hair. The basic shape of head and body were recorded first, then the massive arms, pot belly and a few facial details. The gorilla ambled off almost at once, but filling in the hair, and straw around it was then easy. The drawing took less than five minutes. You might try drawing first in pencil, then pen. Each medium has its own attractions.

Big cats

You already have some experience of drawing domestic felines — now try drawing their larger, more dangerous cousins!

Lions are king of their group, but they are lazy. They leave the bringing up of cubs and most hunting to lionesses. Ladies — what do you mean, 'that sounds familiar'?!

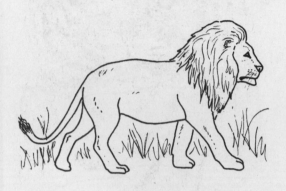

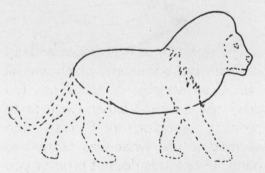

Jot down the basic shape of the male lion before copying in the rest of this majestic, powerful beast. Do you see how similar the shape is to that of the harmless moggy by your side? Beware!

Now draw your version of the gracious lioness below. Notice how I have suggested long grass around her with thin pen strokes. This hungry lioness is out searching for dinner. Does your pet cat look like this when she wants her cat food? Or perhaps when she spots a fly, about to land on the table?

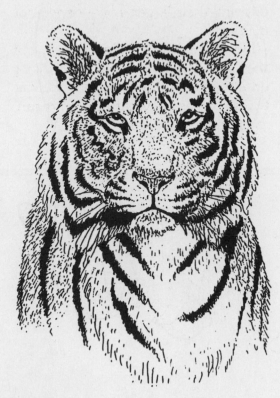

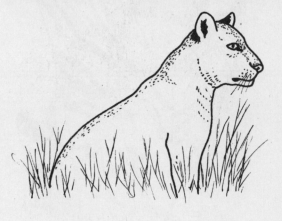

The tiger above was drawn with an ordinary ball point pen, which was all that was available at the time. You don't always need expensive gear to produce a good picture. Picasso often seemed to use what was nearest to hand. I hope this doesn't prompt you to portray the family moggy in the middle of the best lace tablecloth!

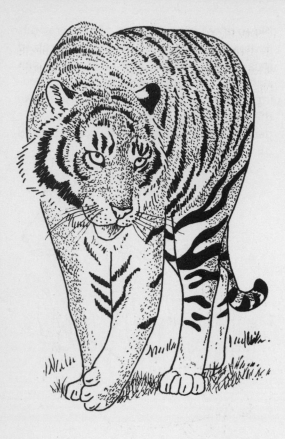

The tiger is one of my favourite animals to study and draw. Above is my sketch of a tiger which was one of seven in a Midland safari park. Have you noticed how a tiger walks with a round-arm action? This is how I drew it. Some of the stripes (those on short hair) are sharp, while others appear more ragged when on thick fur. Notice how I have drawn stripes with close broken lines.

The tiger is a most spectacular animal, but its looks don't stop ruthless men killing it for its skin, and for bones which are ground up then sold as a medicine in Asia.

The bones are no different from those of other animals and are not a medicine. What a waste of wildlife this senseless slaughter is.

Drawing this tiger will be your most advanced picture so far, so go slowly. Start by carefully studying the outline above, then draw it out.

If you were confronted by a tiger, what would you do? Run? No! Most wild animals chase running prey. Try standing perfectly still. Big cats don't attack humans unless they have been wounded or are protecting cubs.

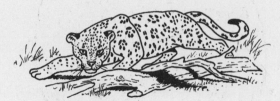

A horse, of course

A horse has a rather complex skull shape, like the elephant, and this tends to confuse beginner artists.

You probably know that a leopard has spots... Did you also know that some of the markings are called rosettes and are made up of four or five spots round a dark centre? Well, now you do! Look at the illustration above to see how small spots cover the face and legs. I drew this animal from a sculpture which was made a few years ago. This leopard is also out hunting — it looks ready to pounce at any moment! Draw your version.

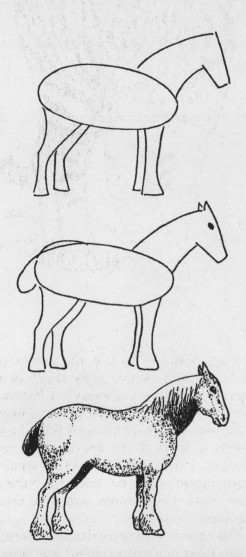

This is one of those wonderful, hefty work horses that are once again becoming popular. Notice how the basic body and head shapes have been drawn with the legs simply done. The finished drawing shows areas blocked in to give shadow under the mane, and on the far legs. The animal was light in colour with dark grey mottling and spots. These were done by tiny dots, smudges and circles. Not too hard, was it?

51

When drawing horses, you should start by careful observation, and think of the head as being wedge shaped, and the body like a rounded oblong, or constructed as an egg shape.

Big fellows

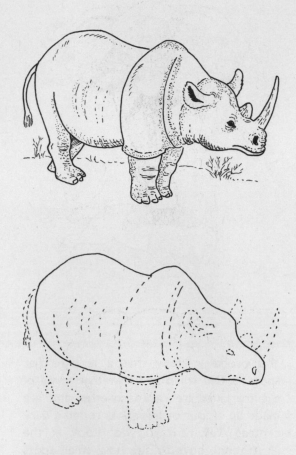

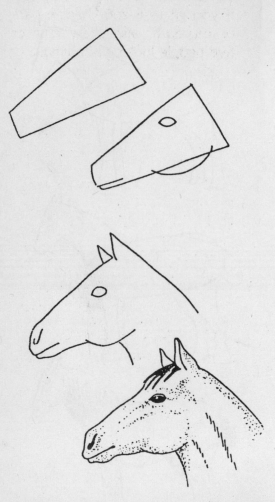

Now try drawing this horse's head. Again we use a wedge shape for the skull outline. Lightly pop in the eye, nostril and cheek. Work more details in until your effort looks like the finished drawing. Rub out stray pencil marks, ink in or leave as a pencil study.

A white rhinoceros (now rare in the wild) is a big, hefty animal which you can see in zoos and wildlife parks. The sleepy-looking rhino above was a zoo inmate. Notice the bumpy back, massive shoulder, two horns and folds in the thick skin. Have a good look at the outlines before attempting to draw it.

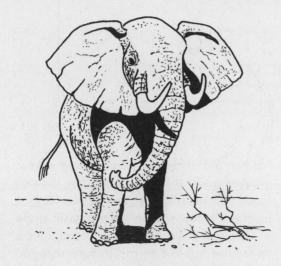

Assignments
1. Draw your own — or a neighbour's — pet, be it cat, dog, hamster or rabbit!
2. Draw four different animals from life, or from good photographs.
3. If you go to a zoo, wildlife park or museum, also draw four or five people looking at animals.

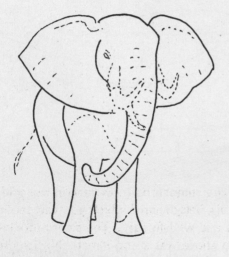

African elephants are the largest animals. They are taller than Asian elephants. I visited a safari park to look at an African bull (male) specimen. He had small, worn-down tusks but I made these much bigger for my sketch above. See how I have used deep shadow to show up the shape of tusk and body. Draw your version.

CHAPTER 8
MIGHTY MONSTERS, PAST AND PRESENT

Whales and other ocean animals are a popular subject for children and adults alike. They are not difficult to draw either!

Biggest in the world
The blue whale is the largest creature on earth. It's even bigger than the dinosaurs which died out years before whales evolved. The blue whale is as long as a jumbo jet. It can grow to 25m, but larger ones have been recorded in the past. To give you an idea of its size, three horses could stand on its tongue. How many traffic wardens do you think could fill its mouth?

The blue whale feeds on a quite small sea creature: a shrimp-like animal called krill which is about as long as your finger. It eats tons of these. The huge mouth takes in fifty bath tubs of water in one gulp. The sea water is then filtered by the hairy bones (baleen) hanging from the top jaw. This gentle giant is warm-blooded and air-breathing like us. It has to come up for air, and, when it does, it blows vapour through the blow hole on the top of its head.

Notice the massive mouth, deep throat grooves (used to help expand the massive mouth), flukes (tail fins), and baleen hanging from the top jaw. Examine the basic shape of this animal (in the upper sketch); it's a streamline fish-like form. I'm sure that you will manage to draw this shape.

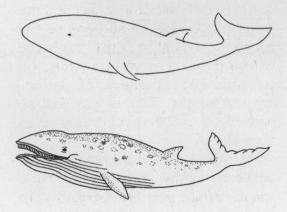

The easy way to draw
The hardest way to draw anything is to look at the outlines (lines surrounding an object) and put them down. To do this is to fail to see the rough shape of the object and then just one line drawn wrong will cause all the following ones to be out. You end up with an inaccurate picture. Yet this is the way most beginners set about drawing.

The right and easy way is to look properly at your subject then ask yourself questions: is it oblong, square, round, pear-shaped, thin, fat and so on? When you have decided what the rough shape is, then you are ready to draw it. If you get this form about right, adding the details becomes the easy part and you will always end up with an accurate illustration. Some people learn to do this straightaway. They are usually the ones who learn to draw in a very short time. You could be just like that.

Drawing is like building something. If you build a small shed, for example, and you get the frame wrong, the door won't fit, the windows will fall out, the roof will let in water and the sides may buckle — all because the frame is wrong! It's just the same with a drawing: if you go wrong on the basic shape (frame or form) nothing else works. This is why *looking* properly is so very important to all artists.

Start your first drawing of a blue whale by lightly sketching the basic shape. When you are satisfied with this, look again at my finished illustration and then pop in all the details: eye, throat grooves, baleen and ridges in the fluke.

Youngsters (or those young at heart!) like to colour their drawings with crayons or pencils, so I shall tell you what colours to use. A blue whale, of course, is called that because it is a pale bluey grey with patches of white barnacle and brown weed on the upper skin. If you want to keep your picture as a pencil study, try using the same method that was explained in Chapter 1: rub on pencil lead with a bit of screwed up paper towel or tissue. Patches of dark sea water can also be treated like this.

Put your name and the date on your finished drawing. It's always useful to look back after a while and see how much you have progressed.

Hunter of the giant squid

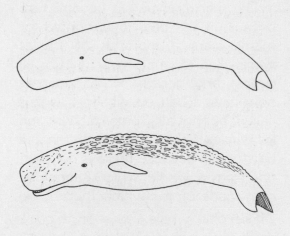

This is what a sperm whale looks like. This animal is another big one: 18m. Draw the sperm whale by first lightly sketching the basic shape, as above. Notice how I have illustrated the skin texture. Copy it to make this a picture good enough to pin on the wall. Perhaps you'd like to colour it in? It is dark grey in colour, although some can be brownish grey. This would be an ideal subject for you to use the technique of rubbing in lead.

Unlike the blue whale, the sperm whale has sharp teeth (fifty in its bottom jaw). It hunts deep down in the inky darkness of the ocean. It likes to feed on giant squid. (Take a squint at one of these fearsome-looking creatures on page 58.)

A sperm whale usually has many cuts and scars on its head, caused by struggles with giant squid which it can swallow whole. The scars are caused by the powerful suckers on the squid's tentacles and arms. This fellow has a massive head, no dorsal fin, a long bony back with wrinkled skin with ridges in it and a row of teeth in the lower jaw.

The sperm whale has become rare because it has been over-hunted for many years. Thousands of whales were killed for their meat, oil (for oil lamps) and bones. Most countries now have a ban on whaling, as it is called, but not all. Some still hunt and kill whales. I believe all hunting should be stopped because there is no product from a whale which cannot be man-made or for which there is no substitute.

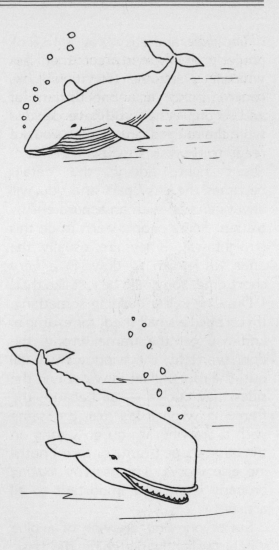

Different views

Now that you have drawn two different whales in profile (from the side), see if you can sketch them from a different angle. It is always good practice to try and look at things — and then to draw them — from a different perspective.

The blue whale is bigger than the sperm whale, so don't be fooled by my putting them both on the same page. Start this drawing by first making a pencil sketch of the basic shapes then popping in the details. I've added small circles and wavy lines to give the impression of air bubbles and rippling water. Add these to your picture too.

Killer whales

You've probably seen an orca, or killer whale, in a film or on television. It has become a popular animal because of its spectacular speed. It's the fastest sea mammal and can reach speeds of 56km per hour (34 mph).

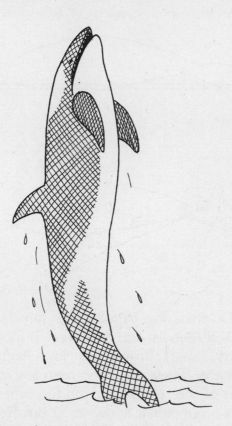

I have drawn a killer whale leaping out of the sea for the illustration above. Notice the front flippers, stiff dorsal fin and black and white markings. Begin your masterpiece by lightly drawing the basic shape, which is like a flattened out C-shape along the back and like a flattened out S-shape down the front. When you've finished your killer whale, add the water ripples and splashes and see how these really bring your picture to life.

The killer whale does not harm humans. Some have been tamed and trained to perform tricks in marinas.

It is found in oceans all over the world where it is a deadly predator which kills seals by the dozen, penguins by the hundred, fish by the thousand and will even attack other whales. We should be glad that it's on our side!

Killer whales often travel in groups, called pods, and seem to have an intelligent brain. Some orcas, for instance, have worked out that they can suck trapped fish from fishermen's trawl nets. Others have been known to work as a team to round up shoals of salmon.

Giant squid

Small squid are caught and eaten by people in many parts of the world. I once tried fried squid when in Italy. I didn't like it at all — the whales can keep it!

Giant squid, however, live in the deepest part of the sea and are not often seen by humans. Some have been discovered inside captured whales. They can grow to be 12m long. That's about twice the width of my house. I wouldn't want them to catch me! They are orange with dark red or brown spots, have large eyes, strange rear fins with turned up ends and powerful suckers on their arms and tentacles.

Work out the rough shape of the giant squid from the illustration below then make a finished drawing by copying mine.

Below is a picture of a dolphin. You will notice the beak-like mouth, rounded forehead, flippers, dorsal fin and fluke (rear tail fins). I'm sure you will have no trouble in sketching this lovely animal. It is pale grey with whitish undersides.

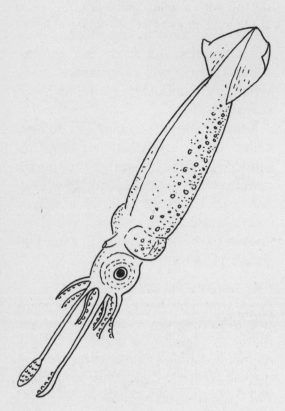

Our friend the dolphin
We all know about dolphins. They are friendly, happy, fun-loving animals which have a brain as large as ours. I can't imagine why some people in distant lands still kill them when they have always been friendly towards humans.

Dolphins live in groups or families, called schools, and are found in most seas, apart from the icy Arctic oceans. They are often seen leaping out of the sea just for the fun of it. I bet you didn't know that dolphins belong to the same family as whales!

Dolphins have been known to defend their young against sharks! They can kill a shark by ramming into it at high speeds.

Your next drawing is a school of dolphins, like those of mine below. See how well balanced three subjects make a drawing?

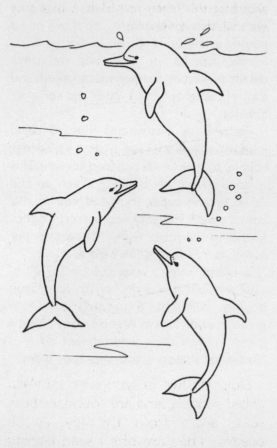

Draw the fish-like shape of the shark, as below. Don't forget to put in the five gills behind the head, or the fins. Despite being called the great white, this fish is pale grey on top with a white underside. You could shade your drawing in by rubbing in lead.

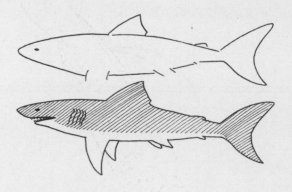

Jaws
One of the most feared creatures of the sea is the great white shark. It has been around for millions of years and is regarded as one of the most efficient predators ever. It can grow to be 10m long and had ancestors twice this size. The great white shark is sensitive to temperature changes and vibrations of all kinds.

More mighty monsters
Now that you have had some practice sketching sea monsters, you are ready to begin work on a few of the mighty monsters of the distant past: dinosaurs. They ruled the world for 140 million years. There were many different sorts and shapes. A lot of people became interested in dinosaurs after seeing the brilliant film *Jurassic Park,* which showed us what living dinosaurs would have looked like. (It also pointed out what can go wrong when man interferes with nature.) Subsequent films and television documentaries are making these beasts almost as familiar to us as present-day animals. The wonders of computer imaging!

Plesiosaurus and chips

One of the big sea monsters of pre-historic times was the tubby plesio-saurus. This whale-like reptile had four flippers, a long neck and tail, but a small head. It wasn't the sort of creature you could catch, fry and have with chips, was it?

Look at the upper illustration of the ple-siosaurus on the left of this page. Notice how I have used bold lines for the basic shape. You should lightly draw this first with a pencil. When you have managed to get this more-or-less right you move on to putting in the parts shown by dotted lines. Simple isn't it? You then add the small details suggesting the eye, mouth, teeth and a bit of background sea water and some air bubbles.

Because my illustrations have to be in ink for publication, I use what is called 'dot stipple' to give an idea of skin texture. This is done by quickly bobbing a pen up and down on the paper. You need not do this with a pencil. The easy way is to rub pencil lead onto the paper with a tissue or paper towel, as you have done before.

It is not known what colour any dino-saur was, but it was unlikely to have been brightly coloured. You could colour it green, grey or brown. A good many animals blend in with their environment so it is harder for their predators to spot them.

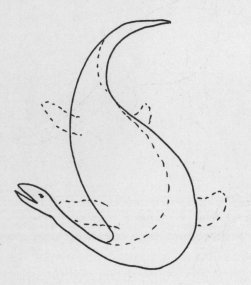

Harmless giant

There used to be a 70 tonne, plant-eating dinosaur called a brachiosaurus which slowly plodded round parts of the world. It was 12m tall — as high as a four-storey house — and 25m long. It was a sort of massive giraffe of the Jurassic period. It had its nose on the top of its head — just think what problems it would have had with a streaming cold!

Brachiosaurus has been shown in films feeding on the top branches of very tall trees. The only defence this huge animal had against meat-eating dinosaurs was a sharp-clawed toe on each foot. It couldn't move quickly, however, so the claws couldn't have been much use against the feared tyrannosaurus rex. A bit like trying to hold off an angry tiger with a pointed twig!

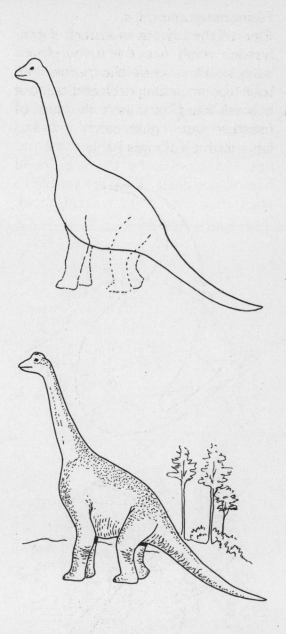

Copy my drawing of a brachiosaurus by first popping down the main shape, as indicated by the strong lines. Remember to use light pencil strokes so that you can easily correct the odd stray line with your eraser. Add the elephant-like legs. Shade with rubbed in pencil lead or colour. It was probably grey, but who really knows? Try adding some trees in the background too. There are tips on how to do these in Chapter 10.

Strange stegosaurus

The stegosaurus was a plant-eating reptile, which was at first thought to have heavy armour plates down its back for protection. Scientists now believe the plates were a form of radiator used to gather in heat and to get rid of it if the animal became too hot. All reptiles, by the way, need heat to get going. They are unable to start their day if it's freezing cold. That's just like me!

Wouldn't it be fun if there were still a few of these dinosaurs around today?

The four large spikes on the end of the tail were used against the flesh-eating dinosaurs that hunted it. It could give a very nasty whack with its tail!

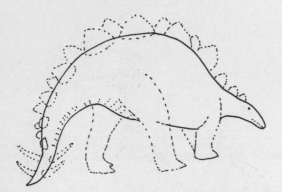

A man-sized dinosaur

There was once a slim, fast-moving, meat-eating dinosaur named sten-onychosaurus (what a mouthful!). This reptile was slightly longer than a tall man. It hunted and fed on small prey. It had two terrible claws sticking up from the back feet. This creature had a large brain and big eyes. Had it continued to evolve it may have ended up as clever as us. Remains of this dinosaur have been found in England.

As you probably know, all dinosaurs suddenly died out about 65 million years ago. The cause is not known but there have been many guesses at the reason.

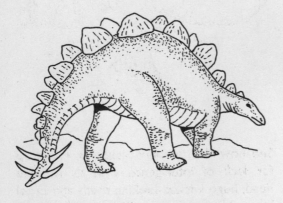

Have a go at drawing this one.

I once met an ex-army officer (he later became a vicar) who, while serving in a remote part of Africa, saw a dinosaur-like reptile which was about 2m high. He told me it was like a giant lizard. What a pity he hadn't been able to draw it. Maybe there are a few unknown monsters still about. Quick, look under your desk!

The most famous dinosaur

Your next project is to draw the famous but terrible tyrannosaurus rex. The name means 'king of tyrant reptiles'. The king was the biggest carnivore (meat eater) ever known on earth. It was 14m long. It hunted and could attack all other dinosaurs but would also eat dead ones it came across. However, it had a small brain. The King was thick!

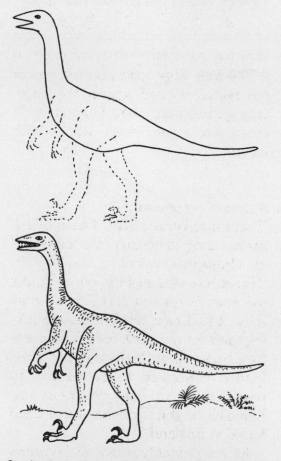

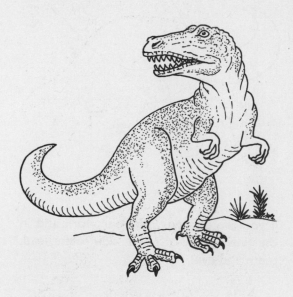

Study this stenonychosaurus before lightly sketching the body, tail and head shape. When you are satisfied with your efforts, draw in legs, feet, claws and eye.

See how the tyrannosaurus rex made up for lack of intelligence with its massive head, huge wicked-looking teeth and cruel claws on the rear legs. The silly little front legs may have been used to help it get up after lying down. Despite its size and weight, it was the fastest of all dinosaurs.

Bit by bit
Drawing tyrannosaurus rex will be your hardest job yet, but if you take it bit by bit you can do it!

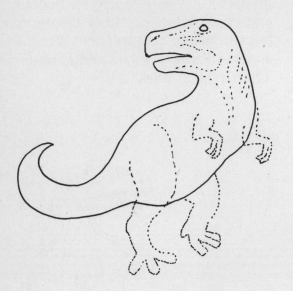

To the left is the main shape in bold lines. Carefully start with this. Check your drawing with mine as you go. Take your time.

Now put in the parts which are shown as dotted lines.

If you are pleased with your work, add in the fine details of claws, skin folds, head, teeth and eye.

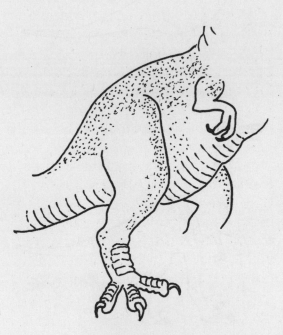

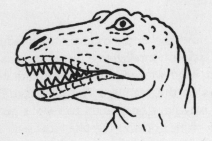

Shade in with pencil lead or colour. It could have been green, brown, striped or spotted. We don't know. Is your finished picture another masterpiece?

Flying dinosaurs

The pterosaur was the largest of the flying animals with a wing span of 12m. I wouldn't like one of these hanging about my garden! Perhaps it's just as well that bats and birds eventually came to be as they are today.

The pterosaur had a furry body with thin arms and legs, and a tail with a kite at the end. The wings were made of stretched skin. The fingers, feet and claws extended beyond the wing edges. The large mouth was filled with sharp teeth.

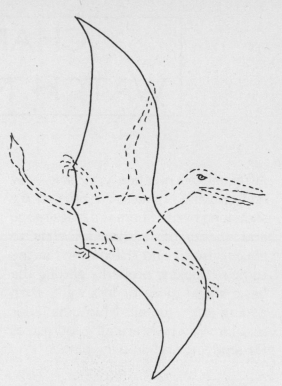

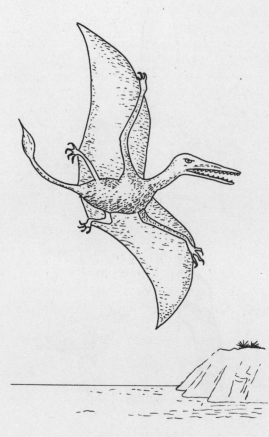

As shown above, you need to begin your drawing by pencilling in the shape of the wings. Once you have done this, carefully start to draw in the dotted parts. I think that the pterosaur was probably brown in colour.

Assignments

1. Draw a blue whale on the surface of the sea, blowing out vapour.
2. Draw a sperm whale having a tussle with a giant squid.
3. Make a drawing of a great white shark being rammed by dolphins.
4. Make one big picture of a tyrannosaurus fighting a stegosaurus. In the sky there is a flying dinosaur. This should keep you busy for a while. Good luck!

CHAPTER 9
WATCH THE BIRDIES

After all the practice you have now had drawing animals, it's time to try sketching birds. There is a huge range and variety of feathered friends to choose from, and the method is the same — looking properly, getting the basic shape more or less right, then adding in the detail. Museums, zoos and bird reserves are all good places for studying and drawing birds.

Be gentle with them
There is one important difference about drawing birds as against animals. It's a little change in technique. Because of a bird's delicate structure, slender legs, feathers and beak, it is necessary to use much finer pencil or pen strokes.

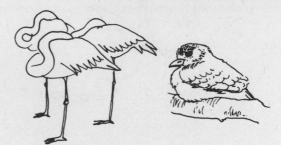

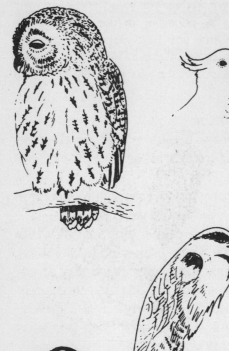

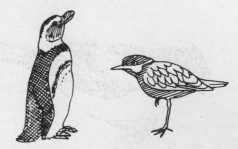

These birds were drawn quickly with light strokes. Notice how much head and body shapes vary between one species and another. Copy or trace these.

Have a go at drawing the marsh tit, which is shown below in stages. This charming small bird is black, white and grey which is good for pencil or pen work.

The robin is considered to be Britain's most popular bird. Each Christmas we see hundreds of cards showing this bright little bundle of feathers. It is much better produced in colour, but it's good practice to do it in black and white. Have a good look at the drawing below, then do your version.

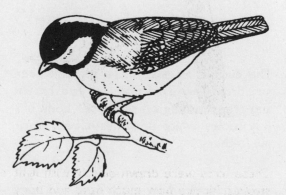

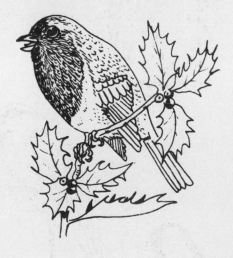

The figure below shows a little ringed plover. This bird nests amongst shore stones and pebbles and is hard to see from even close range, but when it searches for food it darts about very quickly. It has a distinctive high forehead with bold black markings. Try this one in ink.

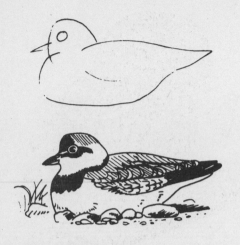

Below is a small shore bird called a knot. These grey-coloured waders are common around our shores, and look very attractive as they rest on one leg with head tucked into wing feathers. The one legged pose is common to many resting birds. Draw this one in ink too.

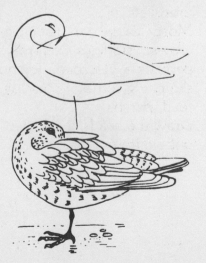

Heads

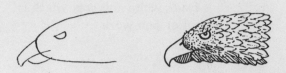

The head in the figure above is that of a golden eagle. Note the flat head, large hooked beak and angry-looking brow which is common to most birds of prey. There is a semi-bald patch in front of and around the eye which has black hairs sprouting from it. The feathers near the eye are tiny but get bigger as they grow on the neck, and are spear shaped. These details can only be seen at close range, or from a dead one, which is how I came to examine one once.

The macaw's head above is quite different in shape — it's rounded and has a thick bill, as have most of the parrot family.

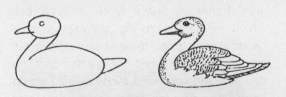

The duck is an easy shape to remember and draw. This particular one had brown and grey mottling on the upper body, but was snowy white underneath, with black tail feathers.

Scraperboard drawings

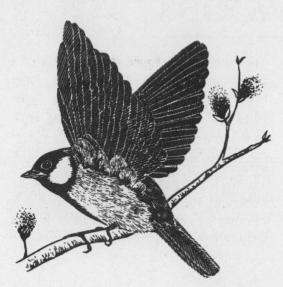

The owl below is another scraperboard drawing. Owls are a very popular subject. Many people collect owl paintings, models and drawings. Copy or trace this picture and see what result you get with whatever you use. Each medium will produce a different picture.

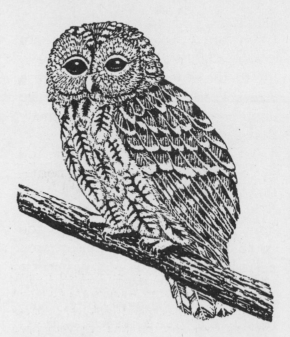

The great tit in the figure above was produced as a scraperboard drawing (see Chapter 15). This medium requires the artist to scratch out the details with a metal tool that can be round, pointed or triangular. In this example, silhouette is first painted in ink on white scraperboard then, when dry, is cut out to give a white, fine detailed picture. The great tit shown was first drawn in pencil from a dead one which had tried to fly through a glass window pane, poor thing. It was pinned out and each primary and tail feather carefully counted and recorded. Most wildlife artists need to go to a lot of trouble to obtain an accurate picture. Try to copy this drawing in pencil or ink.

Assignments

1. Draw a page of garden birds. If you live in a flat, borrow or buy a bird guide book — it will be very useful to you.
2. Most days we see pigeons, crows, starlings, sparrows, or perhaps a blackbird. Try quickly sketching some of these as they feed, perch or fly.
3. Draw the heads, in detail, of four quite different birds.

CHAPTER 10
TO THE WOODS

I am often asked how trees are drawn, so for this chapter we shall go off to the woods. As we explore a forest I will show you how to go about sketching some of the many things we come across.

Art is like a lot of things in life. You get out of it what you put in. Sometimes with a big bonus! Look carefully at what you see, learn about it, draw it well and be a clever clogs. You could become an artist, illustrator, cartoonist, art tutor and writer like me. These nice jobs may not bring the riches of a National Lottery winner, but they give happiness by allowing me to do what I like most.

Trees
Some beginner artists are put off drawing trees because they think them a difficult subject. This is true if you try to draw every leaf, branch and twig. A few budding perfectionists attempt this and end up with a mess. Once you have drawn a tree properly it will stay with you for ever. You can then draw trees from memory.

Trees live
Trees move and sway about in the prevailing wind, and it is usually windy. Daylight shows through foliage, and it's important to remember this.

We have many kinds of tree and could do with more to improve the environment: to benefit our atmosphere by adding oxygen to it; to improve the ground by fertilising it naturally; and to be host to a vast selection of wildlife. For most of us, trees are a joy to see, and to draw.

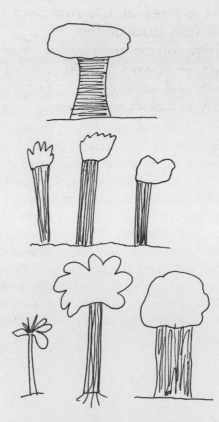

These are tree sketches by children. Some of these look rather like a dollop of ice cream on a rough stick. Adults, by the way, tend to draw trees in the same way!

When tree sketches go wrong it is because the shape and structure of the trees haven't been properly observed or committed to memory. The mistakes are quite common: tree trunks much too thick for the height of the tree; no branches showing; solid looking outline with little suggestion of what the leaves look like. You are about to learn an easy way of solving all these problems.

What shape is it?

The first step, as usual, is to have a good look at your subject. Ask yourself whether it is quite round, tall and pointed like a poplar, or similar to those we see at Christmas with a faded fairy stuck on top.

Trees can be seen almost everywhere — in woods, parks, the countryside and some gardens. There are plenty to look at and sketch.

If you don't have a tree handy to study, start by copying the one below. Put down the basic shape, in ink, with thin, dotted lines, then the trunk. Next add a few branches that are glimpsed through gaps in the leaves. You then suggest the light and dark patches of foliage by using fine shading, blobs and dots. Notice how the deepest shadow is shown simply by blocking in. It's useful to imagine that half the tree is in shadow and half in sunlight. This helps to get depth, and can be used when there's no sun about, as on a typical English summer day!

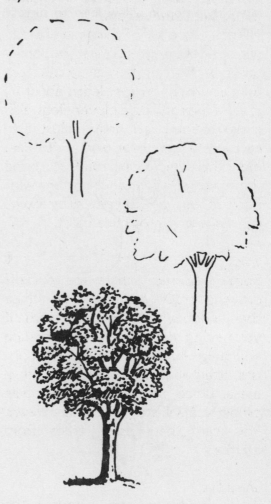

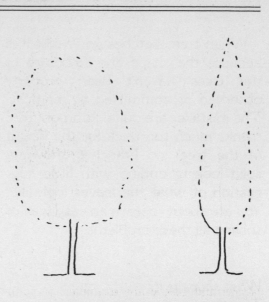

The tree in the sketch below is an oak, which is one of England's oldest and greatest trees. Look at the way I have simplified it. I don't try to draw every leaf, branch or all the details of the trunk. Some shadows are put in. Start to copy this picture by first drawing the ground line. Next put down the trunk and part of some main branches, as in the upper sketch. Make the outline in broken lines of dots. This is important because it will help you prevent making a solid lump, as in the children's sketches. Notice how I have drawn clumps of leaves with small jagged lines. Copy these accurately, then pop in a few lines to suggest bark.

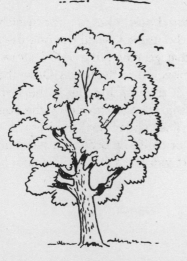

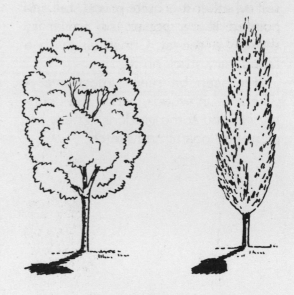

Some trees have a very distinctive shape, like the poplar tree on the right of the illustration above. The branches of this tree grow upwards. The other tree is a lime, which has a nice oval form. The branches of this tree spread up and out. See how I have put in a shadow on one side of each tree, leading out from the roots. Do your usual best copying these trees.

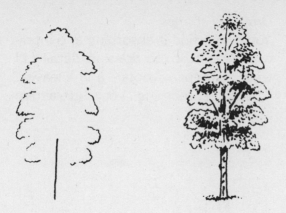

Branch out

The better you know your subject the easier it is to draw. This is why it is important to sketch the individual parts that go into making a tree. You then find that different trees have different branches.

Above and below are examples of some different trees. Draw them in ink using the same technique, then after finishing them try the exercise in soft pencil. See again how leaves are suggested by fine blobs, dots and lines.

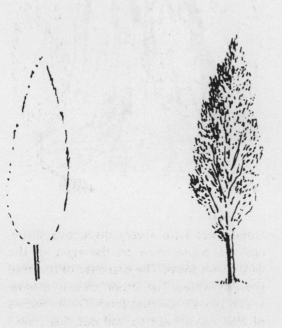

The top branch has a grain which runs along the branch, while the one below has lines that go round the wood. Draw these then move on to the leaves. Draw the basic shape of the leaf then put in the serrations along the edges, followed by the stem and veins. The upper leaf is from a sweet chestnut tree. The other is a sycamore leaf. Haven't you learned a lot in a short time?

A winter's tree

It's easy to see the way trees are constructed in winter when they stand bare against the light (unless they are evergreen), and this is a great time to practise drawing them. There are fewer problems than when leaves are out, but the task takes longer.

Draw old stumps

You might find it absorbing and interesting, as I do, to draw in detail old tree stumps, roots and leaves. There's something very attractive about wood.

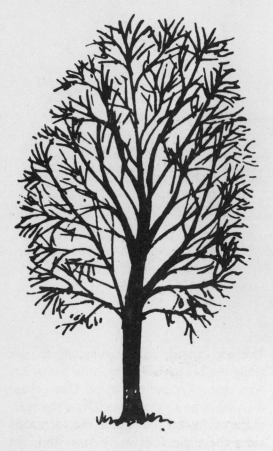

Have a shot at drawing this leafless, wintry tree above or go out and draw one from life, which is much the better way of learning.

This quick sketch, in ink, was made when out rambling, and took about ten minutes. Closer examination shows various degrees of shading and quite large areas of black shadow. Try this or find one of your own to study.

More trees

When you look at trees you will notice that the way they are shaped differs from one species to another. Leaves can be in dense bunches, sparse, drooping down, or growing upwards. All make interesting patterns which have occupied artists for centuries. If you examine the wonderful paintings by John Constable you might think that each individual leaf had been painted in, but this is not so. Constable was so skilled, he gave this impression.

Now it's your turn to record a few more trees for posterity.

Try drawing the trees sketched on this page. These studies were first rapidly done with a soft graphite pencil which, for me, is the best one around for this type of work. (The drawings were repeated in ink for this chapter.) You can get different shades of grey with a soft pencil by increasing or decreasing your pressure on it. This is ideal for trees, but also for rock, brick, animal fur and many other subjects which we shall tackle.

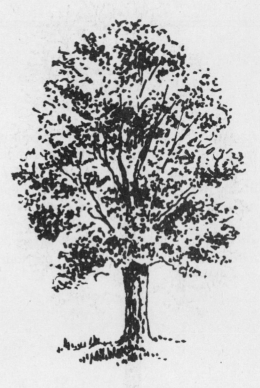

Pencil work is liable to smudge when finished if it is handled, so when you produce an exceptional picture it would be worthwhile fixing the drawing with a light coat of spray. This aid can be had from most stationery or art shops. It's expensive but one container will last a long time, and fix many drawings.

Draw but don't touch

If you walk through a wood in the Autumn you may find fungi sprouting up from the leaf-covered ground. Most fungi are harmless. Some can be eaten. A few of the most spectacular are deadly poisonous.

Above is the poisonous Fly Agaric, which has a bright red dome, speckled with white blobs and spots. The white stem has a mantle round the top. The small one on the right is what they look like after first popping up. Never touch them and avoid kicking them about — you could get a lethal dose of deadly poison on your shoes.

This is called a Death Cap and is yellow-olive in colour. It is even more dangerous than the Fly Agaric because it contains three separate poisons. There is a similar fungi which is pure white. It's called Destroying Angel. The name is no joke folks. No, you can't have it grilled with egg and bacon! Draw these dangerous fungi, then you will be able to recognise them and avoid them.

Creepy crawlies

In woods, countryside, parks and back gardens there are snails and slugs. These creatures are the enemy of keen gardeners, but food for hedgehogs, birds, toads and other animals. You may not be wild about these slimy critters but have a shot at drawing them. They are unusual subjects but fun to sketch.

The snail above has a black body composed of little lumps which I have drawn as tiny circles. The slug has a soft, scale-like pattern on the body. If you want to colour your works of art, the snail is grey or brown with darker markings. This slug is creamy yellow in colour.

Britain's biggest beetle may be seen below. The stag beetle is so called because of its antler-like front mandibles. It measures 5cm. It's almost big enough to wear a collar and lead. Imagine taking three or four of these for walkies! Try to make a full size drawing of the stag beetle. It is shiny black and has six legs, although you can see only three and a half in my drawing.

Butterflies are very popular insects. In the illustration below, the upper butterfly is a peacock. This handsome insect is deep red with black wing patches and eye-like markings of yellow, white and blue. The little butterfly below is a ringlet. It has small yellow rings with black centres on its dark brown wings. Both these butterflies like to lay their eggs on stinging nettles, on which their caterpillars later feed. Try copying these insects, making sure to copy down the basic shape first.

Have you ever seen a dragonfly at close quarters? If not, look at the sketch below. This fast flying insect is quite common but can only be studied when it is at rest on plants which mostly grow near a pond or river. Draw this insect.

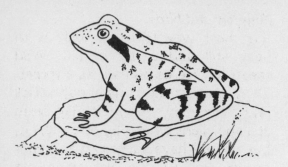

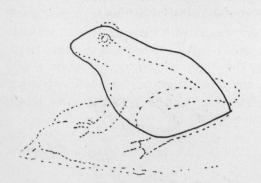

Plants, fruits and flowers

One of the many nice things about going into the great outdoors, whatever the season, is that there are always new things to see and draw. A size A5 sketch pad is ideal to carry around with you.

The common frog is fun to draw. It is becoming rare in places, but can be found near to some pools and ponds. A few days ago I had the good fortune to watch one hop about my garden. I'm pleased because it feeds on slugs and insects. I do not own a pond but there is one several doors away. Froggy had been around all summer but should have been underground sleeping throughout the winter. A warm, mild day had brought it out. It was pale brown with dark brown markings, the underside being cream coloured. The large eyes were yellow. Notice that I always try to leave a tiny white spot in the pupil of the eye to give the eye a look of life. It applies to all animal drawings. Try to make your frog study a little masterpiece.

In the autumn you can find many fruits about. The sketch above shows a conker, acorns and blackberries. I am sure you can work out the basic shapes to build each drawing. Try your hand as a botanical illustrator (there's a posh title for you!).

In the Spring I look forward to seeing the first early wild flowers in woods and countryside. An attractive plant, found near footpaths, is the pink bindweed. This is the upper plant shown in the sketch below. The leaves are fresh green and the flowers pale pink.

The lower illustration is my study of a primrose. This is yellow with dark green leaves which are heavily veined. Copy my drawings by doing a bit at a time, very carefully.

Animals and birds

The best way to see wildlife is to keep still and partly hidden. Wild creatures see us humans as a threat. They are also nervous about noises and movement. A wood may seem still and silent when you first enter it, but do as I have suggested and very quickly you will be pleased to see many different animals.

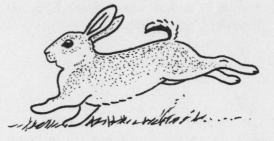

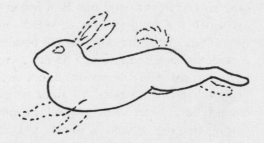

A common creature around our countryside is the rabbit. You must have seen these pretty animals bounding away when you disturb them. I have used this sight for the illustration above. Notice the black-backed white tail of the rabbit. It flips backwards as a warning when it is startled (a deer does the same thing). I am sure you will find this easy to draw. Go about it in the normal way.

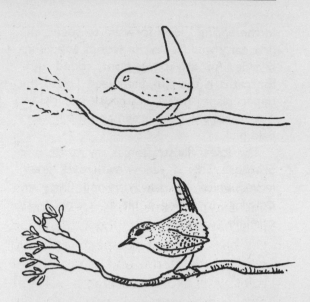

There are several kinds of deer in this country. One that I have seen in woods is the roe deer. This graceful little animal is about the size of a big dog. It is highly nervous but can be watched early in the morning or at dusk when it feeds. Copy my sketch of a roe above.

You can see scores of different species of birds in a wood, but there isn't space in this book to include them all. Our smallest feathered friend, the wren (shown above), is coloured in shades of brown with light bars on its wings. Draw your version of my illustration.

Assignments

1. Draw a tree which is near your home. Keep it simple.
2. Draw a flower from life.
3. Look about for an insect, bird or animal, then draw it. Is there a fat spider in your bath?
4. Find and draw an old tree stump, root or piece of grained wood, in ink and pencil.

A colourful pheasant is shown above. This lovely bird has a blue-black head and neck with a white band round it. The red body, wings and tail have black or dark brown markings. Notice how simply I have drawn it, with no fussy details.

DRAW ME

CHAPTER 11
BEGINNING LANDSCAPES

Before we move on to getting out and drawing some landscape scenery, it is important that you understand the basic rules of perspective. If you don't understand and apply these rules, your work as an artist will suffer. If, however, you can grasp the basic idea, your drawing will improve no end.

When we see trees as part of a landscape, out in the lovely countryside, we know that the tree which is nearest to us appears to be large, while those in the distance are small to our eyes. In order to draw this correctly we need to know a little about perspective. Perspective applies to anything we draw — humans, animals or still life. Usually it is a word that strikes terror into the hearts of newcomers to art, but it's not difficult to learn.

By now you will have already drawn perspective automatically into many of your life sketches by simply putting down what you saw, so don't be afraid to learn the theory.

If, for example, you were standing in the middle of a straight road and looking ahead into the distance, an imaginary line drawn level with your eyes would be the eye level. All parallel lines to your left and right would appear to converge to a point dead centre of the eye level, and this is called the vanishing point.

Suppose that on your left hand side is a row of pointed trees that stretch down the road to as far as you can see, then the lines disappear into the vanishing point, as shown below.

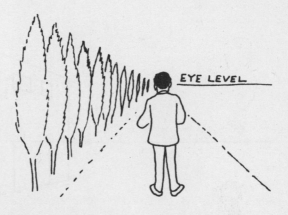

The sketch below shows how the rules of perspective apply to a landscape with trees. Can you spot the vanishing point?

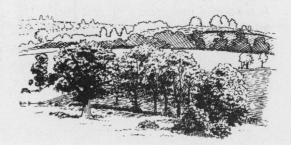

Vanishing point of buildings
If you stood and looked at a concrete, oblong building, as below, your eye-level would be the bold horizontal line. Note how all the sloping lines (dotted) meet then vanish at two points on the eye-level. There may be one vanishing point, or more than one, in any picture. These disappearing lines affect the way windows, walls, doors and so on are drawn. They are necessary in all drawings, particularly drawings of buildings.

The lower sketch in the illustration below shows the same building but without the dotted lines. See how people appear to become smaller the further away they are. To get to know about this subject, try a few checks as you are out and about. Hold a pen or pencil along the edge of a roof that you see before you, or along the kerb, road, or pavement. You will notice at once how lines meet at the vanishing point on your eye level.

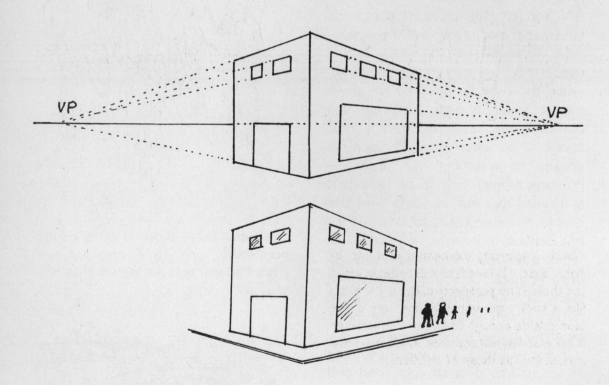

Common mistakes with perspective

Below is my re-drawing of Katie's picture. Notice how the leading figure, the winner, appears to be bigger than the lad coming in second who, in turn, is larger than the girl in third place. At the far end of the field there are tiny spectators. This is how perspective affects the drawing of people. See how the track lanes seem to converge together as they go back into the distance. These lines would eventually meet up and vanish to a point on the horizon.

Above, a sporting moment is captured by Katie, aged 11. Her figure drawing is good, but there is no perspective. The track looks like a back wall with thin lines on it. The tape is wide enough to flatten a contestant. Such mistakes are common in adults' drawings, as well as those of children.

83

Eye level

Imagine that you are at the seaside. There is a ship on the horizon, and you sit down to look at it. You would see what the small child below sees. You then stand up to get a better view. Your scene would be like that of the lady in the centre. Finally, you jump up onto a big rock. Now you see the same as the man on the right.

I have used a sketch by Nicole, aged 7, for the illustration above. It's a scene of a winner and losers in a track race. The winner smiles but the girl who is back of the pack cries. Another runner has collapsed in a heap. What jolly fun! Why is this picture wrong? It is wrong because no rules of perspective have been used. The sports field and runners are seen from a bird's eye view. We don't see things this way.

What have you learned from this? The straight line of the horizon, which is also the eye-level, remains the same for the child, lady or man. This line is level with their eyes, whatever their height. However, it is obvious that the taller you are, or the higher your viewpoint, the more can be seen.

When you set out to draw a picture, always keep your head at the same level so that your eye-line will remain the same throughout your sketch. Either sit or stand, but stay in the same position. You could be looking straight at your subject or up or down at it. It doesn't make any difference so long as your eye-level stays the same.

All this may seem confusing to you, but don't panic. There is an easy way of working out perspectives. Study the illustration below. My garden shed was used for this example. I stood in my kitchen looking out. I held a pencil in my hand, closed my left eye (because I'm right handed and my right eye is my master eye) then held it to match all sloping lines. This then gave me a good idea of how the perspective lines ran.

My pencil was laid on the paper at the same angles. It requires a little practice but you will soon get the hang of it.

Perspective applies to everything we see. Try the above method in your home. Look at a table and work out the sloping lines with your pencil. It works. You will quickly find out a lot about perspective by checking things out with a pencil.

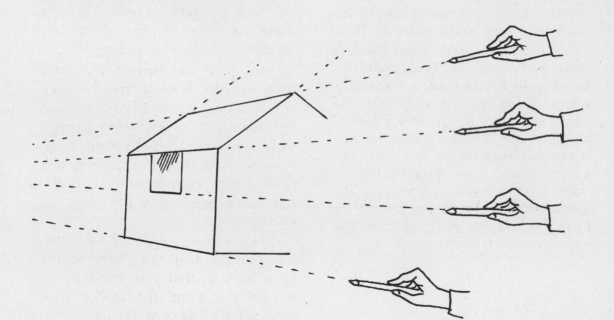

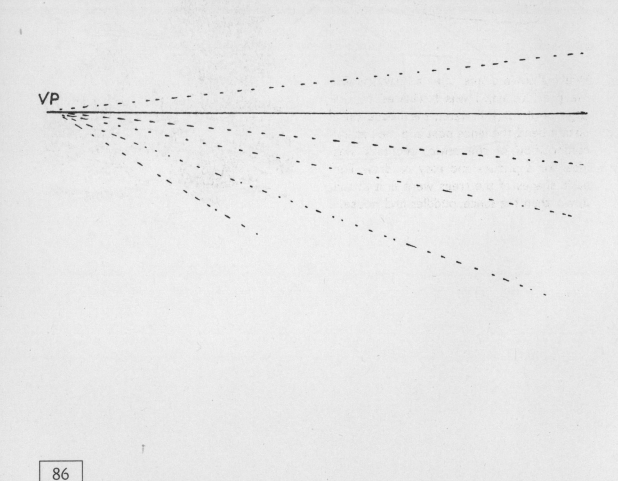

The drawing above is of a simple landscape. There is a row of trees with a hedge which gradually becomes smaller then disappears to a vanishing point in the distance. There is a line of fence posts, a small lane and muddy furrows in a field, all of which end up at the same vanishing point. The illustration below will show you all these perspective lines. Now you have an idea of how perspective applies to landscape drawings.

VP

Watery landscapes
Most of the landscape scenes I have depicted in this book include water, so I will explore this seemingly tricky subject first.

Walking down a lane, after a heavy rainfall the previous day, I was fascinated by the large pools of still water, the house on a distant bend, the fence post and the natural composition of the environment. It was ideal for a picture and easy to draw. The basic shapes of the trees were first jotted down, then the fence, puddles and house.

When drawing still water, remember that it reflects what is around it. In the illustration below, these reflections were put in by using horizontal lines which are close together for dense shadow and further apart for other reflections. You have to think it out when working and, of course, make good use of fine cross hatching, dots and lines. Notice how delicate it is. See how grass in the foreground is bigger and more pronounced the nearer it is to the artist. The house has shaded sides, there is deep shadow beneath the tree suggesting that the sun was almost overhead, which, in fact, it was. Strong contrasts of dark and light give the effect of depth. Try copying the illustration straight off with a pen.

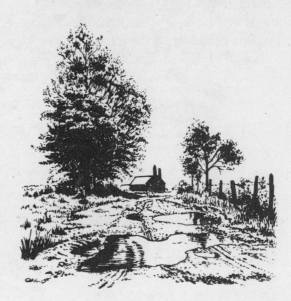

Moving water

The waterfall with trees, rocks and water on the left was drawn with a broader nib pen simply because it was the only one to hand at the time. Notice how it appears to be quite bold, compared to the picture below, yet it captures the scene. The shading is more open than in the other example. The water needs to be shown as moving. This is done by using small, curved lines to suggest ripples. Patches of blocking in also help.

The scene on the right is one side of an estuary. The sea nearest to the eye is shown as wavy lines with just a bit of blocking in. Patches of seaweed on the beach are easily done by using a series of small circles, dots and blobs. The same technique is used to depict forest in the distance. Isn't it easy — when you know how?

When water is shallow and disturbed, as in the illustration on the left, the artist is faced with a lengthy job. The dark shadows are put in with lots of wavy lines, then filling some of them in. Possibly the hardest thing about recording water scenes is the patience required, not the actual drawing.

The lock on the right took over an hour to draw, due to all the shading required. See the cross hatching on the walls, and the way reflections were put in. Just to test your staying power, try this one in ink.

Have a look at the sketch to the right. Here, reflections were done by many horizontal lines, oblongs and ovals. There is always more than one way of doing things, so feel free to do your own thing when it comes to shading. We all have our own unique style.

I'm one of life's little sunflowers, so on a very cold day I stayed inside the car to draw this scene on the left. Don't tell anyone! This picture was needed for a book on rambling! The work took over an hour, similar to the lock, but what a different picture. It's a study of very fine cross hatching and shading of all sorts. A drawing like this is good practice. Bridges and tunnels offer a different challenge. It pays to try everything.

This picture is reproduced, with permission, from "Let's Walk" by Mark Linley, formerly published by Meridian Books.

Clouds as well

Many landscapes should contain clouds. But expertise is only gained by doing lots of drawings, and most days in our climate we have clouds to see. Notice how clouds have dark, light and medium tone areas; how some edges are sharp, some blurred. These can be drawn as broken, dotted or thin lines, depending on what you want. Clouds can be drawn with a soft pencil which can be smudged with a finger to give the right effect. Often, however, a good ink drawing is enhanced by putting in clouds, so don't be afraid to do this.

The ink sketch above was done from a photograph, shortly after a walking holiday. Notice how shading has been used on the rocks, and how a few, small horizontal lines can suggest sea in the background. It's the simple ways that are the most effective in many drawings. Beginners tend to want to try and show every detail. While this is perfectly natural, it's also the commonest mistake. An illusion of depth, in this illustration, is helped by the tuft of grass in the foreground. It was from this point that the photograph was taken. A camera is very useful for the busy artist who runs out of time, and sees far more than can be drawn in the time available.

The sketch above was made after a walk on Exmoor. It was early Spring, with billowing clouds, bare trees and rolling, open hills. Pictures like this are easy to do if kept simple, with attention to things like branches and hedges.

The coastal scene below was drawn from a cliff top, and presented no difficult problems. Normal shading and attention to flowers and grass in the foreground were all that was required. Again it's quicker and more effective to do a drawing with as few lines as possible, but to remember light and dark for depth.

Always try to take a sketch book with you on holiday or when visiting unusual places or events. There's certain to be something worth recording, and it may be weeks, months or years before the same environment is seen again. Very often, drawings done 'on spec' can come in useful long after they have been produced — for illustrating books or articles, or for exhibiting, for example.

A camera

A camera is ideal for the artist who travels and wants a wide angle shot of the countryside or of buildings. Even inexpensive cameras give quite superb photographs, and with automatic focus are almost totally foolproof for those who know nothing about this skill.

A big landscape

Newcomers to landscape art sometimes become confused when faced with a vast panorama, but there's one dodge worth knowing. Choose your picture by deciding what points should mark the edges of your work. Or, better still, make a rough square with your hands (as below) and view possible compositions through it. This trick is useful on all pictures, not just landscapes. By moving the hands near to you or away, the size can be adjusted. Then you can get on with your masterpiece and ignore surrounding distractions.

Keep notes

It is worthwhile to keep notes of the things that might come in handy for a picture: old wooden gates, fences, farm buildings, and people. All can add much to a picture, and it's enjoyable practice — the more you do, the better and faster you become.

Assignments

1. Imagine that you are a goal keeper. Draw what you would see.
2. Draw part of a building which shows some perspective lines.
3. Draw two scenes from old calendars or postcards. Keep them simple.
4. Draw two scenes with trees and water, from life.
5. Make some notes of clouds that you see. Use ink and pencil.

Don't forget that a picture can be given a sense of scale by including the figure of a person, or an animal. Notice the difference that the rambler in the picture below makes by covering him over briefly with your finger. Try making a good copy of this picture, adding a person, or even a few sheep on the hills. Remember the rules of perspective.

CHAPTER 12
IF IT'S STILL, DRAW IT

Still life is an art form in its own right, and whole books have been devoted to this subject. It is very traditional to churn out the odd picture of bowls of fruit, bottle with glass, tea cups, vases of flowers etc., but many people have been put off this fascinating pastime by having the subject badly taught or thrust at them when at school.

The subjects for this book have been chosen because they can be used in many general pictures, and are good exercises as well.

Don't eat it first
I found that a newly baked loaf of bread as a background to a hunk of cheese was an excellent model. The trouble was that it got eaten before the drawing was finished. Some of us artists are greedy, or just plain starving!

Collect old wood
Old wooden gates are among my favourite items to draw. The ancient bars and pieces show wonderful grain lines with lots of different tones, then there's the added attraction of bygone craftsmanship that went into the making of them. Many new gates are made of steel because it's cheaper and lasts longer than wood.

With old gates there are usually equally elderly posts which are lovely to sketch.

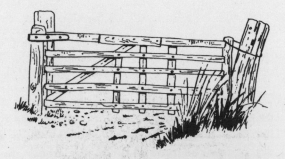

Try drawing this old wooden gate or, better still, go out and find one to draw from life.

Dead tree stumps, fence posts, roots and branches are other subjects which are easy to draw. Driftwood that has been cleaned by river or sea then bleached by the sun is attractive to sketch. Some shops sell pieces of this as highly varnished, highly priced ornaments.

The branch shown above was found on the banks of an estuary. It's very useful indeed to keep ink sketches of objects such as this because they can be added to pictures to improve composition or fill in gaps.

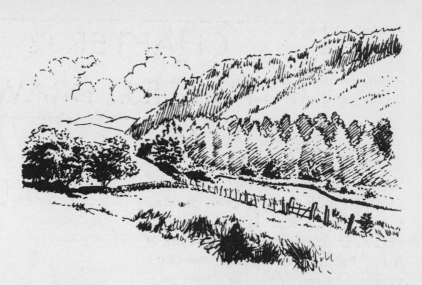

Notice how fence posts and battered gates add a little to the drawings on the right and below. Try copying these scenes, or finding similar to draw from life.

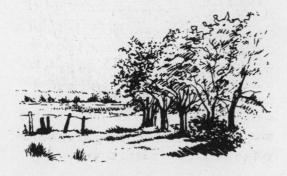

I use a fine pointed pen for this work and have found that by decreasing finger pressure on the pen, very thin, delicate lines can be produced. This is a help in recording, for example, the fine lines of wood grain, or those seen in leaves or flowers.

Examine the posts on the right. Bits of bark, cracks and knots in the wood all help to make an attractive drawing. Try your hand by copying these, then look around for some to do from life.

An unusual tree, on a windless day, is a good still life subject. In the sketch below, the leaves were shaded in, just to try something different — which is to be recommended in most art forms.

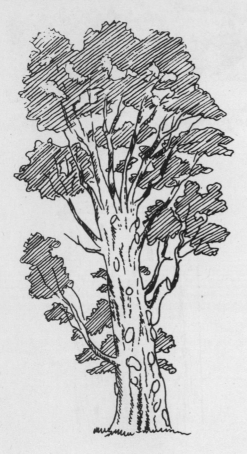

Ivy leaves are nice to draw and make pretty compositions, like these below. You often come across this plant on buildings, trees and old fences. Again, you can add them into pictures with good effect. Start with the basic shape of the leaves, as shown above, then simply put in the details.

Plants

Notes made of plants and flowers can be very useful for pictures. These are not hard to draw provided that you look carefully first, as I'm sure you now do. First put down an accurate basic shape then work it into a finished drawing. Always follow the same procedure, then it becomes a good habit. I'm no botanist and quickly forget the proper names of plants and flowers, but this doesn't stop me from admiring and drawing them.

Flowers

Generally speaking, flowers are much easier to draw than to paint. If drawn, the first thing is getting down the correct basic shape. Then add in the details of petals, stems and so on. But to paint flowers is a harder task — many colours may be required and dozens of tones. Female artists often shine at this, possibly because they can have a more delicate touch than men.

Draw flowers by using those around you, which may be in a garden, window box, pot, or good photograph. Perhaps you could use this as a good excuse to buy some pretty flowers for the special lady in your life — whether that is your wife, girlfriend, mother or even yourself!

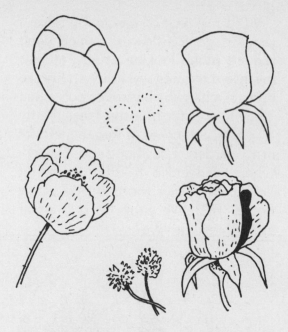

Take a look at the flowers above then try to draw some different ones of your own choosing, using the same easy system.

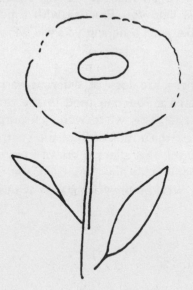

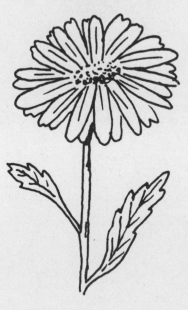

This white flower with an orange centre, sketched above, is an ox eye daisy, I am told.

With my lack of gardening skills, I tend to go for flowers which don't require much looking after. Petunias fall into this category. I buy enough to bung in a hanging basket or container. They flower for months, bless them.

I once had scores of forget-me-nots in my garden. They hung about everywhere. I decided to thin them out drastically. Now there isn't a single flower left! We can't be brilliant at everything, can we?

The sketch above should show you how to draw the pretty forget-me-not. The difficult part is drawing the thin stems. This is where practice at making sweeping lines will help you. Practise with a pencil first. Take your time and you will win.

There are lots of different variations of petunia. The one used in the drawing on the left was white with rich purple markings which radiate from the centre of each flower. This effect is drawn in by using dot stipple with tiny lines. Glance at the rough drawing before having a go at this one.

Grass

Fruit

Clumps of grass are fine to draw and useful for putting in the foreground of pictures. The grass in the sketch above is of the ordinary lawn sort, left to run wild. You guessed right, it's a bit of my lawn!

Fruits of all sorts crop up in still life pictures. I was instantly attracted to great bunches of delicious looking blackberries when out in the countryside, and made the ink drawing above. Notice how this simple subject can be a study of strong contrasts, black and white. When this picture was finished, I ate them!

Assignments

1. Draw a page full of plants from life, if possible.
2. Do the same with old fences, gates or posts.
3. Draw studies of dead branches.

CHAPTER 13
BUILDINGS

Old buildings, for me, have far more charm, character and art than modern plastic and glass erections that are thrown up all too often today. This chapter is about drawing the sort of thing that brings a glisten to the artistic eye.

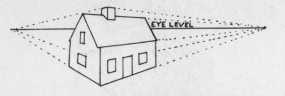

More perspective
You will remember that we learned something about perspective in Chapter 11. We need to brush up on that knowledge for sketching buildings, but there's no need to call for a strong drink or reach for an aspirin, it won't be painful or too difficult!

The illustration above should remind you how to put in the lines of perspective, leading to vanishing points at eye level. The sketch below shows you how to deal with perspective that is to one side of you, rather than in front. A row of trees is used; notice how the dotted lines vanish into the eye level. Try a few drawings which show things in perspective — your garden shed, a bus shelter, or your garage.

Get it right
The would-be masterpiece of your great aunt's thatched cottage in the country, with roses round the door, will look quite wrong if the perspective is incorrect. All the lines of roof, windows, doors, sides, etc. must converge to a vanishing point on your eye level at the time you make the picture. This eye level will stay the same, unless you jump up and down, climb a ladder or drop into a hole! Once it's fixed, all lines will lead to it.

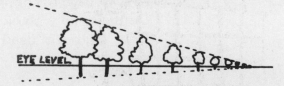

Put in the lines lightly with a soft HB pencil which can be erased when your drawing is right.

Bits of buildings
You may be full of confidence by now and feel able to tackle a whole building straight off, but if you are not it's good practice to start by drawing a page or two of building parts.

When you are drawing buildings, or anything else, ask yourself three questions: What shape is it? What shadows are there? How can I achieve that effect? If problems like these are thought out first (and it's done in seconds), the picture will be that much easier.

It's useful to collect notes of stone, brick and walls. These can be used in future drawings. It's always good to keep your best sketches. For example, many of the fast ink drawings in my note pad have been used to illustrate this and other books. *Sketches may become valuable to you.*

Draw old ruins
A good way to begin drawing buildings is to have a look at old ruins, such as ancient castles.

Try copying these bits of buildings, then get out there and find some of your own to fill your page. Look for interesting or unusual shapes and styles.

Above is part of Dudley Castle (the zoo is within its grounds), and it was drawn during the afternoon spent making sketches for the animal pictures in this book.

The drawing below of an old, tumbledown barn was done from the inside of my car (it was another cold day!).

Old farm buildings, churches, cottages, bridges, mills and so on are lovely to see and draw. A journey into rural areas will soon reward you.

Start by drawing the perspective, in pencil, then the main parts, roof, sides, chimney, doors and windows. Add in details of brick or stone work last, but don't overdo this, just suggest a few. Finish the picture with trees, bushes, flowers or whatever you see.

Let there be light (and shadow)
All pictures need contrast of light and dark, or shadow, particularly buildings. If there is no bright daylight or sun you can still put this in, but get it right. Shadow that is near to you tends to look lighter than that away from you. You must decide whether to block it in or shade it.

The figures above show how shadow falls away from the light.

Indoor lighting

While we're on the subject of light-ing, you might wonder whether you require special lamps or bulbs for indoor sketching — not really. A good, even light is fine; not too bright, and not too dull. Fluorescent tube lights are good, or a table or desk light. I usually manage with what is around, but never work in poor or half light.

Specialise

Some people coming into art try the various subjects previously covered in this book, but suddenly shine when drawing buildings. Then they devote almost all their future efforts to this interest. If you are taken this way, by all means follow your star, but don't neglect other subjects. It might be wonderful to draw the perfect pic-ture of your Great Aunt's thatched cottage, but it's not so good if the roses round the door look like a tat-tered wreath because you haven't bothered with flowers.

Assignments
1. Draw a page of building parts from life.
2. Draw a building from life, with background.

As you've worked so hard in the last few chapters, drawing sensible, grown-up pictures, I think it's about time to lighten the mood and draw something a little more fun — and childlike. The following exercises should appeal to little boys and girls of all ages — so long as you are young at heart!

Boys' choice

Some subjects which boys like to draw are quite different from those chosen by girls. This is not something new. It has always happened. Many moons ago schoolboys sketched pilots, soldiers, cowboys and Indians. Today, fantasy spacemen, spacecraft, zombies, skeletons and the like are featured in drawings. Cartoons and animals, however, have remained ever popular with boys and girls.

Action

Boys often draw modern sportsmen in action, so let's take a look at how best to go about tackling your favourite sports hero. One of the easiest ways to capture an action figure — that is, one involved in running, jumping or moving in some way — is to start by drawing a stick figure.

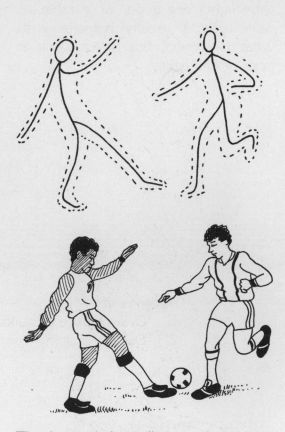

The drawings above illustrate a two stage method of constructing action men. The top sketch is of stick figures (bold lines) which have been first drawn then enclosed by a dotted outline of the whole form. To copy these, begin with stick men, then draw dotted outlines of the figures and erase your stick men. Finish as in my illustration.

To find out for yourself how this works, collect old sports pages of newspapers. Then draw stick men on top of the photographs. Follow this with a dotted outline of the figure, as in my sketches.

Use the same method to produce your version of the cricketer above. You can use this trick to make drawings of any human doing just about anything!

Go into space
Youngsters find space exploration and science fiction interesting subjects to draw.

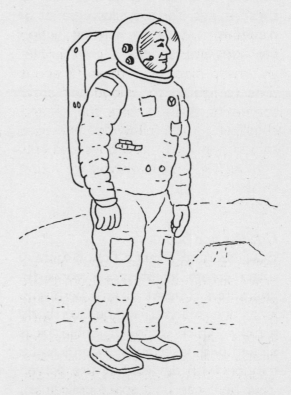

The sketch above shows how an astronaut should appear when drawn. The suit has eleven layers of material in it, which make it very bulky. Imagine going out wearing eleven suits! Notice the construction of a space helmet and the life support pack which an astronaut must carry. Draw your version of an astronaut, either space walking or on the moon.

I have seen several sketches by boys of weird and wonderful space ships and transporters. If you invent such a craft, be sure to make it clear what sort of power unit it has and whether it flies, floats or is a land vehicle. It could, of course, do all these things. You are allowed a lot of freedom in creating science fiction cartoons and stories.

My space ship, above, was based on the famous Shuttle, with a few of my own ideas thrown in. Copy this or invent your own spacecraft. It's great fun!

Goodies and baddies

Boys keen on science fiction fantasy often create all sorts of wonderful characters. There's often a hero who is a one man army: he has body armour which is indestructible; he is armed with laser guns, swords and a cannon with devastating fire power. Your hero can be a space policeman, terminator, soldier, enforcer or whatever you want.

The baddies are sometimes skeletons, fearsome animals or aliens, or are thuggish-looking villains who wear suits of armour like those used by ancient knights.

Above are two goodies and two baddies. See how I have drawn these, then either copy mine or come up with your own inventions.

On the right is my idea of an average, unbeatable space hero. I'm sure that you can invent a better one by adding to a copy of my drawing. Give it a try.

My space villain, below, is a kind of monster dinosaur. There is a UFO swooping around in the background. Now you invent a space baddie.

Girls' choice
Girls tend to draw subjects they know or see. Homes, gardens, countryside, clothes and fashions, which are often quite adult, feature in their sketches. Girls, of course, mature quicker than boys, so this isn't surprising.

This isn't to say, of course, that all girls only like drawing flowers and cottages — if you are a girl (or, indeed, an adult woman) and you prefer drawing spaceships and man-eating dinosaurs, by all means go back and draw whatever makes you smile! And boys, if you prefer sketching fashion designs, keep it up — some of the most brilliant fashion designers are men!

Outdoors

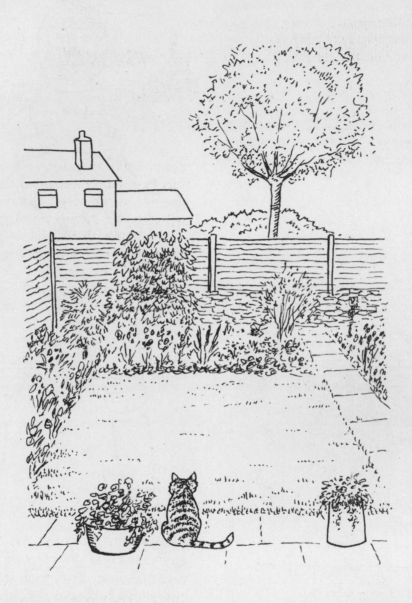

Look carefully at the sketch above. This is my drawing of a small garden, as seen from a kitchen window. There is a patio with two plant tubs and a moggy keeping an eye on his territory. Notice how the path, lawn and flower beds have been drawn in perspective. It is a common scene, but one which can give a beginner trouble, usually because the laws of perspective have not been applied and everything has been attempted in too great detail.

See how I have drawn plants, shrubs, grass and climbing ivy by using what I call controlled scribble. This is done by making small ovals, semi circles and short strokes. It works because it suggests what the marks represent. Try it out when you copy this picture.

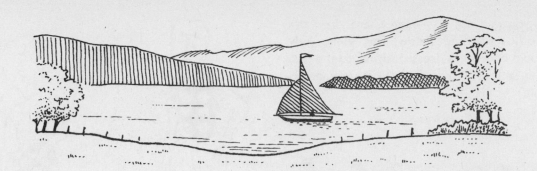

Simple landscapes, like the one above, are easy to invent. Professional artists use what they see to compose a picture, rather than trying to copy exactly what is before them. You can take things out — power lines, telegraph poles, TV aerials and the like. You can move trees or pop them in, reshape mountains, lakes or rivers. Some of the greatest artists of all time had a brilliant talent for changing a very ordinary scene into a dazzling masterpiece. You could become one of them! Draw your version of the coastal scene above.

Clothes sense
Unlike most boys, girls usually have a keen interest in clothes, hairstyles and make-up. They look at the sort of thing which would appeal after leaving school behind. Very wise.

When drawing buildings, another trick of the trade is to use a ruler to put down all the straight lines first. Then these lines are drawn over by hand so that a mechanical-looking sketch is avoided. Use this method to copy the cottage above.

A young designer, named Clare, drew the clothes featured below. This young lady could become a dress designer to the rich and famous. Wouldn't that be a glamorous job?

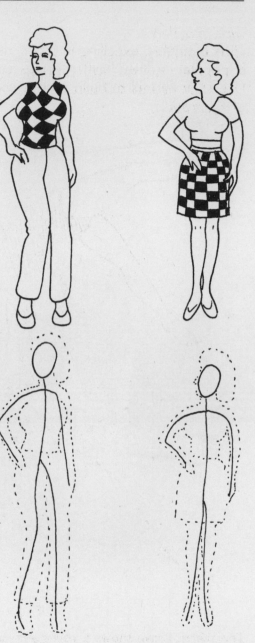

Clare's inventions are made up of straight lines which are pleasant to look at, but such designs change when worn by a human. Would-be dress designers need to learn how to draw fashion model figures on which to display their work. Look at the drawings on the right to see how straight lines become curved when on a rounded human figure.

If dress designs interest you, learn how to draw simple human figures. You can construct these by using stick figures then building on them, as in the lower drawing of the illustration above. Copy these sketches for practice.

Girls in action
Girls in action, excelling in sport, are a popular subject with youngsters. Use stick figures to build up this sort of illustration.

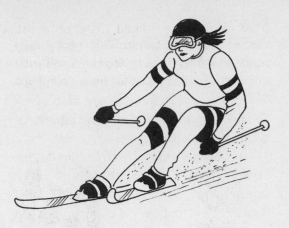

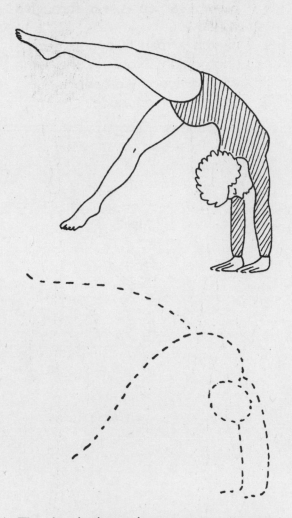

Above is my sketch of a female skier. Use a stick figure to copy this one, and the ballerina below.

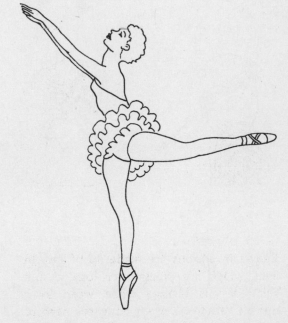

The sketch above shows a young gymnast doing a handstand. I would have great problems doing this, would you? Observe the unusual shape of the stick figure before copying this drawing.

Styles

Fashion styles, particularly for teen-age girls and young women, change almost faster than the weather! Make-up and hairstyles are also quick to alter, but are mostly variations of what has gone before.

To become good at drawing hairstyles, *look* carefully then pop down what you see in a simple way. Remember to have a sharp point on your pencil before sketching fine lines of hair.

Assignments

1. Draw a sportsman in action.
2. Imagine being on a distant planet. Draw what you would see.
3. Draw a garden as seen through a window.
4. Sketch a man in action from a photograph. Now do the same with an action woman!
5. Draw a fashion model.

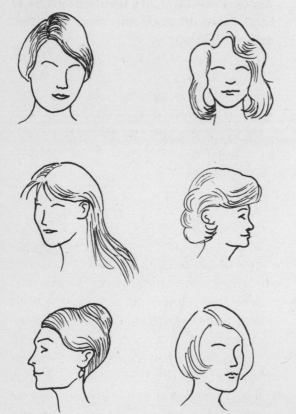

I'M FROM SPACE

It isn't necessary to draw each individual strand of hair (there are thousands of them!). Just suggest a few, as above. Learn how to draw heads and faces in a simple way. Copy the models above.

CHAPTER 15
SCRAPE IT OUT

Scraperboard (called scratchboard in the USA) is a super medium for producing animal pictures because one can get an illusion of real fur or feathers. We saw how this works for birds on page 69.

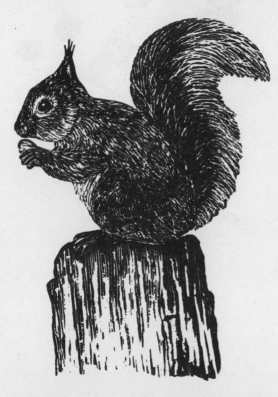

This squirrel was made using scraperboard — see how convincing the fur looks. This image has been produced as a Christmas card.

The material is made up on cardboard. The manufacturers keep the ingredients secret, but it's generally thought to be a mixture of plaster which is baked onto a surface. It is very hard and brittle and cracks if bent or dropped. Care is needed when working with it.

The picture is cut or scratched out with a steel nib-like tool which can be triangular, pointed or curved. In fact, any sharp point will do, but I have always preferred the triangular blade for normal work, and a curved one for clearing large areas.

Black scraperboard
The black scraperboard gives a picture of white against black, of course. It shows the smallest mark and mistakes can rarely be put right, so it's very important to get the basic drawing correct. I do this by drawing out on tracing paper, in ink, exactly what I want the finished picture to look like. Then I rub chalk on the reverse side of the paper. This is to obtain a result similar to using carbon paper, but white on black, of course. The drawing is then transferred to the scraperboard with a fine pen, or pointed tool. There is then a white-lined drawing to cut out or scratch. The squirrel was done this way.

Years ago, before the days of modern print making, many very famous artists did magazine and paper illustrations with scraperboard. It is one of my favourite mediums, and one to be recommended to all aspiring artists. It is comparatively expensive today, so careful planning and drawing of the design to be scratched out are essential.

White scraperboard

Some beginners trying this art form buy white scraperboard and attempt to cut out a picture, only to find that the board has been ruined by their efforts. White board must first have the design painted on as a black silhouette which, when dry, is then scratched off to reveal the white board below. It's best to use quick-drying ink. This is a very good medium for birds. Landscapes can be done with scraperboard as well.

One big advantage of this medium is that it mass-produces well and allows very fine lines to be used. On an animal picture, for example, there are about twenty-five tiny cuts to the square centimetre, and these lines must go the same way as the fur grows on the real thing.

Below is a little marsh tit, made using white scraperboard. This starts off as a black silhouette, then the main lines are cut in and the rest carefully scratched away. Branches are drawn with a fine pen, but leaves cut away. Notice how the lines in the leaves go all one way; this is shading, in effect. A master drawing of this bird, in ink, was constantly referred to as the work went on.

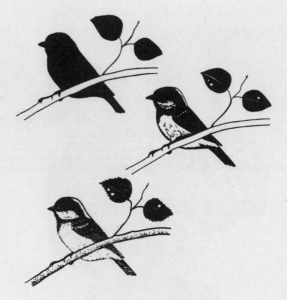

Foil

Scraperboard comes in foil as well. This gives a gleaming picture when cut away. I don't particularly like this, and find it not so good for wildlife pictures, but maybe it's just because I've used black or white for many years now.

Method

The way to cut is quite natural — you hold the tool just like a pen and scratch away. It causes a fine layer of dust to settle everywhere — over the table, the cat, and up the artist's nose! Blow it away from time to time — this helps!

Assignment

Buy a packet of black, white or foil scraperboard from your local art shop and try it out on whatever you fancy.

CHAPTER 16
CARTOONS FOR FUN

Of all the mediums I have tried, cartoons give the most freedom to express one's own thing. It's not necessary to stick to lifelike proportions, or even to try to get a likeness. You can invent exactly what you like, and have fun doing so. Your little cartoon people can have gigantic noses, huge eyes or feet, three fingered hands and so on.

It's wonderful to be able to create little people and control their lives and times. If your cartoon ideas amuse you, then you can be pretty sure that they will brighten the days of other folks with a sense of humour.

Style
When you have drawn a few hundred sketches, your own style of drawing will have evolved which will be quite unique to you. I have known style happen with some students after just a few lessons. This particular way you record things will affect what your cartoons are like. My own natural style is rather lifelike, and I admire other cartoonists' work far more, but it's what has evolved for me, and it gets me by.

You might have an off-beat style that is funny to look at without captions. If you have, the publishing world is at your feet.

You may be capable of inventing an original strip cartoon, like Peanuts with the dog Snoopy. These characters made their creator a multi-millionaire.

Funny faces
Good cartoons, however exaggerated, are based on life. So start by drawing a page of cartoon faces which stem from those you see about you; your spouse, children, grandparents, friends, or even strangers. Look first, then draw very fast because this seems to give the best results for cartoons.

The faces below were done during a lunch break when on a ramble. They are true likenesses.

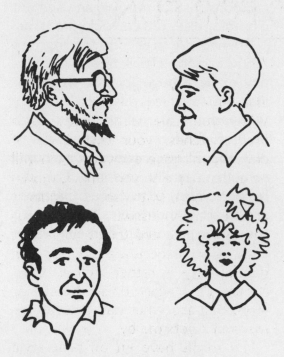

Don't bother, at first, trying for likenesses. This is called caricaturing and it is advanced art. Feel free to invent new, funny faces, and then have a go at stretching them to their limits.

Be careful
Drawing cartoons is great fun, but it can bring trouble if you are not careful, and I wasn't when at school. I was clipped round the ear for drawing a cartoon of a master. Later, when in the army, I had the bad luck to serve under the meanest sergeant major ever. The poor chap was very ugly and seemed to hate all soldiers in general, and me in particular. To me he resembled a loathsome-looking bald headed vulture, so naturally I drew him this way. The masterpiece was stolen and then pinned up in the sergeant's mess. It was not signed, but all my weekend passes were cancelled for six months, and were spent doing dirty, awful jobs. There's no justice for some of us cartoonists!

Most normal folk, I'm pleased to tell you, are delighted to be cartooned, and I'm sure a small fortune awaits me on a sunny Spanish beach during the tourist season.

All of us have seen thousands of animal characters in films, books, magazines and on TV. In spite of this massive saturation, beginner artists tend to think it is a hard subject, but it isn't really. Base your comics on real life.

Press cartooning
A large proportion of the cartoons used by daily newspapers are produced by talented spare-time artists. The competition is staggering though. Some editors receive several thousand cartoons each week, but may use at the most about 35.

I churned out newspaper cartoons for a number of years, and it's difficult work. The easy part was the drawing, but after a hard day it was difficult to think out new ideas of different slants on popular themes.

The rewards are high. Most national papers pay well for good ideas, but in order to sell one cartoon it's necessary to produce scores.

It works like this: to break into newspapers, a batch of 5 or 6 cartoons, with return postage, are sent each week until the editor accepts one. This can take months, even

years. Editors like to be sure that your work is *your* work before beginning to accept. Don't be put off by constant rejections, just plod away. If you have an original style and good ideas, you could break in quickly.

Animals
Try turning some of your sketches into animal cartoons.

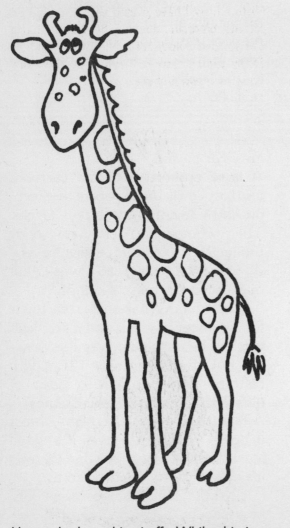

Have a look at this giraffe. While this is a true cartoon, notice how near to life it is.

Make them funny
When a zoo or wildlife park is visited I always turn a few of the studies into cartoons, just for my own amusement if nothing else. You could do the same.

Animals are great for turning into funny cartoon characters. Walt Disney made a huge fortune from this idea. You too might raise a little money with comical animal drawings. Try a few just for fun. The best way is to play about with a pencil or pen until something finally emerges. This can happen quickly or take ages. Cartoons are an art in themselves, and express the unique personality of their creator.

Above are my cartoons of a giraffe and a leopard. I try to keep drawings like these as simple as possible. This is my style. You don't have to copy them exactly. Try to invent your own cartoons of these two creatures.

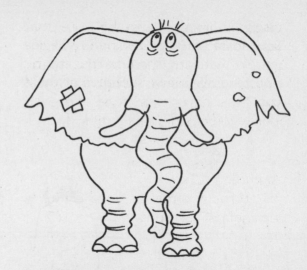

Notice how I have placed the eyes high up on the elephant above. The golden eagle and vulture below are two more examples of my cartoon style. Draw your own versions of these animals.

The vulture above was produced by a student after one visit to a zoo, and with no previous experience of animal cartooning. It's a bit of animal magic.

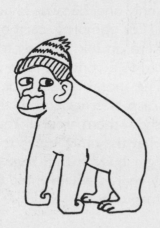

It doesn't take much to change animals into cartoons: this ape has been given a woolly hat and big eyes. Try something different on your version.

119

Human animals
In wildlife parks or zoos you will see people watching the animals, and it's fine to draw a few sketches of them too.

Have a go at drawing some human animals of your own!

Ideas
Thinking out original cartoon ideas requires time. Your mind has to adjust to the job, but when you do get the hang of it, keep a notebook handy or the idea will be lost forever.

The best ideas, I have found, are always those that come from life. In fact, all good humour is based on truth. You can get ideas simply by listening to what people say or watching what they do.

As an example of how chance situations can give rise to the inspiration for cartoons, I once had a great idea while out with friends on a ramble. A group of us trudged across a huge field of clay, and had to keep stopping to knock the stuff off our boots. After crossing over, I heard a lady say triumphantly to her husband, "It's your turn to clean our boots". The idea was ready-made, and it often happens just like that. The drawing was done during a lunch stop and appears in my old book, *Let's Walk*, and here on the next page. That was not the only one, because I had about 16 ideas for rambling cartoons and drew them, in ink, in a sketchbook. These led to a contract for a walking book. The moral of this true tale is *always keep sketches* and, if they are funny, show them around. You never know what they might lead to.

Now get busy with a page or two of funny characters invented by your fertile imagination.

This picture is reproduced, with permission, from *Let's Walk* by Mark Linley, formerly published by Meridian Books.

Assignments
1. Try looking at animals then turning them into comic ones.
2. Take a good look at yourself in a mirror then draw what you see as a cartoon — and no cheating!

CHAPTER 17
FINAL REMINDERS

Congratulations on reaching the last chapter, and on all your work to date. Have you remembered to put the date on your sketches? Now is the time to look back at your very first effort then compare it with your latest creation.

Some newcomers to art are a bit short on self-criticism because they lack experience to see small mistakes. If you think that you are too kind to yourself, and we all are at times, ask a good artist or teacher to give you an honest opinion. This can come as a nasty shock. But don't worry if it does, just learn from it. No true artist ever stops learning.

If, like me, you are never really satisfied with what you have produced, do not worry because you will always make progress.

Look carefully first

The much repeated *look carefully* is again reiterated as a vital part of being, or becoming, a good artist. If the drawing goes wrong it's almost certainly due to wavering concentration or not looking properly. Look again my friend — you can get it right.

Draw quickly

Fast, spontaneous drawings (particularly with cartoons) are usually the best and have an extra something about them which is sometimes missing from careful work. To go too slowly is to encourage doubt to creep in. Be bold, be quick.

Draw plenty

As mentioned before, the more you draw, the better you become. Quantity leads to quality in this case.

Many of my week-course students draw 200 sketches in five days, and most top the 100 mark. Some have said that drawing becomes addictive, and maybe this is true. If so, what better addiction is there for an artist?

Develop the good habit of always carrying a small sketch pad with you, and filling odd minutes by jotting down what is around you. You will make progress and have professional-looking work to show.

Keep the best

In the course of a year you can build up a huge pile of drawings, so it is wise to weed out the bad ones and keep the best to compare with future efforts. Try keeping them in pads which are dated. Later, you too can become a writer and illustrate your books with drawings taken from your sketch pads.

Enjoy it

I believe that one of the secrets of quick learning is to enjoy your subject, and to enjoy doing it. Don't let it become too serious, or worry about volume of work — just plod on and use your sense of humour as you go. With the right mental attitude you will then always look forward to the next lesson or session, and making mistakes won't bother you because you will take them in your stride and expect them.

Have courage

You should have the courage of your convictions as an artist, and I'm sure that you will have the nerve to go to any place and draw anywhere, regardless of what other people think or do. You might, for instance, decide to stand in a busy street and sketch folk around you. This can be fun and not nerve-racking at all: in fact, strangers may smile and talk to you — just because you are an artist. It's one of the many perks of the trade.

If you want to try something different, go ahead and do it. You might discover a new art form or medium that will sweep the world. New ventures can lead to many things.

Just going out and drawing from life brings rewards. You may, for example, meet many interesting people and like souls. You learn about life, and record it. Now rush out and make a start.

Use your own computer

Always try to use that wonderful built-in computer in your head, your sub-conscious mind. Its magic power is there for you to use. Remember that your conscious mind is its master. Your sub-conscious mind is your servant, and quite foolproof when given the right instructions. It can work for good or bad, depending on how you think. But, as most of us artists are peaceful, caring humans, you will program your computer for good. *You can learn to do anything*; never forget it.

Finally, thank you for being my student and for reading this book. Good luck with all your artistic endeavours.

GOOD LUCK

Also available in the *Right Way* series:

THE RIGHT WAY TO INTERPRET YOUR DREAMS

Dr Elizabeth Scott draws from significant research to help you discover the origin of your nightmares, night terrors and repetitive anxiety dreams, using a practical, non-mystic approach.

HOW TO SOLVE CRYPTIC CROSSWORDS

Explains step-by-step all the various sorts of clue you are likely to encounter. Shows you how to recognise each type and how to solve them, with example crosswords to check your progress.

THE NEW BOOK OF IQ TESTS

Ten challenging new IQ tests from professional Puzzle Editors Philip Carter and Ken Russell. Clear answers and explanations are given. Ideal for those practising for interviews or exams, or simply wishing to probe the depths of their mind's capacity.

FOOTBALL SKILLS: One-to-one Teaching for the Young Soccer Player

How to excel at soccer for players aged 7 to 17, their parents, teachers or coaches. Ralph Brammer's **Football Skills** is a unique route to improve a youngster's game, with great ways for an adult to help.

TRACK DOWN YOUR ANCESTORS:
Draw Up Your Family Tree

Assemble a full family history by consulting the registries of Births, Marriages and Deaths in Great Britain, Census returns, the Public Record Office, Wills, Probate, old newspapers and other sources.

THE RIGHT WAY TO READ MUSIC

From the first note you read to the beginnings of harmony, musical theory simplified into logical steps for the beginner, or those taking GCSE Music or Theory examinations.

In the *Right Way Plus* series:

IMPROVE YOUR PIANO PLAYING

Eradicate recurring mistakes; master the art of good fingering, expressive touch, phrasing, tone production and pedalling; and learn new pieces using a simple and successful technique.

UPHOLSTERY PROPERLY EXPLAINED

For foam, hair and hessian upholstery, Anne Brock reveals many tricks and shortcuts. Clear illustrations and step-by-step instructions for beginners and more experienced upholsterers alike.

RIGHT WAY
PUBLISHING POLICY

HOW WE SELECT TITLES

RIGHT WAY consider carefully every deserving manuscript. Where an author is an authority on his subject but an inexperienced writer, we provide first-class editorial help. The standards we set make sure that every **RIGHT WAY** book is practical, easy to understand, concise, informative and delightful to read. Our specialist artists are skilled at creating simple illustrations which augment the text wherever necessary.

CONSISTENT QUALITY

At every reprint our books are updated where appropriate, giving our authors the opportunity to include new information.

FAST DELIVERY

We sell **RIGHT WAY** books to the best bookshops throughout the world. It may be that your bookseller has run out of stock of a particular title. If so, he can order more from us at any time – we have a fine reputation for "same day" despatch, and we supply any order, however small (even a single copy), to any bookseller who has an account with us. We prefer you to buy from your bookseller, as this reminds him of the strong underlying public demand for **RIGHT WAY** books. However, you can order direct from us by post or by phone with a credit card.

FREE

If you would like an up-to-date list of all **RIGHT WAY** titles currently available, please send a stamped self-addressed envelope to

ELLIOT RIGHT WAY BOOKS, BRIGHTON ROAD, LOWER KINGSWOOD, TADWORTH, SURREY, KT20 6TD, U.K.
or visit our website at www.right-way.co.uk